Wearing History

Wearing History

T-SHIRTS *from the* GAY RIGHTS MOVEMENT

STEVE GDULA

alyson books
NEW YORK

This trade paperback original is published by Alyson Books
245 West 17th Street, New York, NY 10011

Distribution in the United Kingdom
by Turnaround Publisher Services Ltd
Unit 3, Olympia Trading Estate
Coburg Road, Wood Green
London N22 6TZ England

First edition: August 2007

07 08 09 10 11 **a** 10 9 8 7 6 5 4 3 2 1

ISBN: 1-59350-995-9
ISBN-13: 978-1-59350-995-6

Library of Congress Cataloging-in-Publication date are on file.

Cover design by Victor Mingovits

For Lon and Sammy and Jacob—
and everyone who made and wore these shirts.

TABLE OF CONTENTS

We Are What We Wear

A LOT CAN BE LEARNED about a society by simply looking at what people wear. Whether wittingly or not, cultures wear their morals, politics, economics, and status on their collective sleeves. These factors become so ingrained and influence modes of dress to such a degree, that they become the uniform of a particular people, of a particular place, at a particular time. In the process, these elements, and the clothes that they inform, become assimilated enough into day-to-day life that they barely register. It's only when an individual, or a smaller section of that culture breaks from the norm that we are likely to take notice.

In the twenty-first century it's difficult to cause a stir through one's clothes. So many modes of dress have gone in and out of style that one of the few remaining offenses a person can commit through attire is to be caught somewhere in that neverland between a trend's death and its inevitable rebirth.

One surefire way to get a reaction, though, is by making a statement, literally. Branding a T-shirt with a provocative image or slogan, especially if it rankles another's religious beliefs or political sensibilities, is still the stuff that can get kids expelled from school or make the nightly news.

As a society, how we view such actions—do we agree with the sentiment or slogan or do we find it offensive, do we admire the wearer's guts or are we appalled by their gall—depends on our vantage point. Looking back today at T-shirts that simply said "gay pride week '77," the first thing that might register is the retro style of the letter font or its relatively small, yet clear, image. Or maybe the lack of an accompanying graphic might cause us to interpret the "pride" declaration as tepid, maybe even meek when compared to T-shirts that commemorate such celebrations now. Yet wearing anything that identified the wearer as homosexual, never mind a T-shirt that expressed pride in one's gay or

lesbian orientation, was taking an incredible risk at the time. The year 1977 was witness to very public denouncements against homosexuals and their rights. A backlash against the little ground the gay rights movement had gained in its nascent years was resulting in men and women losing their jobs. Gay-bashing incidents, at least the ones that were actually reported, were often registered with less than sympathetic police departments. A young man in San Francisco was stabbed to death as his murderer chanted, "Faggot! Faggot! Faggot!" while he repeatedly thrust a knife into his victim.

Considering the social climate at the time, the simple statement of "gay pride week '77" T-shirt was a defiant declaration. The T-shirt carrying its imprint survives today because someone saw it as more than a political statement, more than memorabilia. It was kept as a reminder of a personal history that played a part in a movement's history, the history of the call for gay and lesbian equal rights. It is now, as it was then, a historical document of a minority's struggle.

I found that T-shirt, along with hundreds of others, while doing research at the Gay, Lesbian, Bisexual, Transgender Historical Society's archives in San Francisco. Box upon box labeled T-shirts held not only the personal artifacts of the

individuals who wore them, they contained the ephemera of an era.

These were pieces of a bigger history, personal as well as cultural, on little patches of cloth. As I began diving into the boxes, I realized I was pulling out chapters of a story. That story of course was the struggle for rights and acceptance as lived by the GLBT persons who'd experienced the issues firsthand. Looking at shirts lampooning the anti-gay campaign of Anita Bryant and her Florida Orange Juice spokesperson status, I realized how much courage it took for the persons who wore these shirts to do so in public; as mentioned before 1977 wasn't the most welcoming of years for sexual minorities.

Wearing an item of clothing could be dangerous to your health.

I found shirts endorsing early gay political groups, shirts advertising gay bars, and shirts commemorating gay pride celebrations. And I also found T-shirts memorializing Harvey Milk, shirts honoring those who'd died from AIDS, and shirts holding accountable the individuals who'd allowed the disease to spread unchecked.

There were messages of love, messages of humor, messages of anger, and messages of hope. There were food stains, sweat stains and, occasionally, holes in the shirts. The wear-and-tear of the clothes only added to their significance. They

were all worn with conviction.

I could look at these shirts and know the stories behind them, but sadly I couldn't know anything more about the brave individuals who'd worn them as many of the items had belonged to someone now deceased. Their personal treasures were donated to the archives, by family or friends, after their deaths. I knew their struggles as I'd had some of the same, but I couldn't know their personal tales. I only knew their experiences were part of the greater whole. I also knew I wanted to share the images of these shirts even though it was an unconventional approach to telling the story of the GLBT community's pursuit of equality.

WEARING HISTORY IS by no means a thorough examination of the gay rights movement of the last thirty plus years. Instead it is an overview of some of the significant and key events that occurred, especially those moments that were represented by the T-shirts in the GLBT Historical Society's archives. Also, the events chosen for inclusion generally entailed a level of visibility and openness on the part of those persons which keeps with the theme of this narrative. Readers looking for detailed histories should consult any of the excellent titles listed in the references in the back.

A note on language: I have used "gay," "gay and lesbian,"

"gay rights movement" and "GLBT community" interchangeably as inclusive terms in some areas to avoid repetition except where the usage required an exclusive reference to gay men or gay men and lesbians.

> My favorite gay-themed T-shirt that I wore was a Keith Haring where the figures had male and female signs for heads and they were linked male/male, female/female. My favorite Keith Haring shirt is one I wore in an 80s action movie called *Band of the Hand*. The shirt was ambiguous but seemed fully gay to me!

JOHN CAMERON MITCHELL

actor, director, filmmaker, musician
Hedwig and the Angry Inch and *Shortbus*

First Steps

THE YEAR WAS 1964. Society as most Americans knew it, was well on its way to being turned upside down. That year Bob Dylan sang, "The times they are a-changin'," and one didn't have to look very far to see the proof. The evidence was in the country's newspapers, in the streets of its towns and often right under the roofs of its homes.

Civil Rights marchers had taken to the streets to protest racial inequality. Vietnam War protestors staged sit-ins, demanding world peace. And a small minority that had been pleading its case in courtrooms and calling for justice via orderly picket lines was

coalescing into a movement. Gays and lesbians, who had been meeting since the last decade in groups like The Mattachine Society and The Daughters of Bilitis, were coming together as one, and by the summer of 1964 the love that had dared not speak its name, not to mention its practitioners, was featured in a major spread in LIFE magazine.

"Homosexuality in America," as LIFE's article was called, might not have been at first glance a convincing platform to advance the cause of equal rights for gays and lesbians. But despite the condescending and at times hostile tone the writer took towards his subjects, the article's publication was evidence that when it came to the presence of gays in America, the mainstream media had taken notice. Acknowledging the minority's call for equality was another matter entirely but homosexuals were registering on the culture's radar. Getting that culture to pay attention would take several years and more than a few photos in a magazine spread, but by the decade's end, the revolution—while not necessarily televised—was underway. And the newly empowered gay rights movement had a galvanizing event to memorialize their cause, a flag to fly over their gatherings, and a very effective means of getting their messages heard.

GAYS AND LESBIANS attending rallies calling for homosexual rights in the 1950s and 1960s were given the dress code for the day; skirts for women, jackets and ties for men. Adherence was mandatory. Deviation was not an option. The Mattachine Society, one of the earliest homosexual rights activist groups and one of the first organizers of marches, was intent on projecting a public image that conveyed conformity to society's norms. Demonstrators were to walk in an orderly fashion, their appearance neat and their manners in check.

As a uniform for acceptance, their clothing and carriage could not have been more respectable. But as a uniform for change, their attire lacked impact. It carried no punch. What was more status quo than the unthreatening workaday togs of the business world? In the less-than-receptive climate of the 1950s and early 1960s homosexuals were slowly inching out of the closet, one cautious step at a time. But to rock the boat and characterize themselves—either through dress or behavior—as anything other than quiet, orderly, law-abiding citizens who simply wanted the same rights as everyone else was viewed by some gay leaders as being counter to their cause. Society didn't need any further encouragement to disapprove of homosexuals. "Retaining the

3

EVEN AS A BLANK SLATE, the humble white T-shirt carried a powerful message of its own in the 1950s and 60s. After World War II, the T-shirt had become part of the uniform of a certain segment of society, as the practice of wearing underwear as outerwear became associated with the social outsider.

T-shirts, issued to every soldier in World War I and II, had always been symbols of masculinity. Now in the post-War era, revolutionaries and members of the counterculture turned the garment into the foundation for a new type of uniform. In movies Marlon Brando and James Dean had made the T-shirt edgy and hip, and now rebels, regardless of their cause, emulated their matinee idols' appearance and their attitude. In the gay community, some men were not only worshipping Brando's image but trying to remake themselves in it, as well.

"Remember T-shirt sales after *Streetcar Named Desire*?" writer Sam Winston asked in the pages of *The Advocate* in 1967. "I was nearly trampled," he wrote as he recalled

his experience of being caught in the retail stampede of gay men storming to buy the new sexy symbol.

Underneath a leather jacket, or tucked into a pair of jeans, the T-shirt became almost as mythologized as the male ideal it was associated with—the soldier, the laborer, the biker—in the fifties and sixties. The new portrayals of objects of male affection, and arousal, as drawn by Tom of Finland, wore tight fitting Tees, as did the members of the biker gang in Kenneth Anger's homoerotic S&M flick *Scorpio Rising*. The cruising narrator of Ralph Pomeroy's "Corner," likewise tried to appear detached and cool as his "levis bake[d] and his T- shirt sweat."

T-shirts conveyed an image of alienation, despite the fraternal association that could be derived by its connection to decidedly male groups such as military ranks or biker gangs. What started to broaden the shirts' appeal was the potential they held as billboards—and they were readily available. The war effort had built factories that could mass-produce anything and everything needed for the military, including soldiers' uniforms. After the war ended, a surplus of jackets, pants and even T-shirts were available in second-hand clothing stores, thrift stores and Army Surplus stores. Now suppliers to major retail outlets had the means to quickly, and affordably, produce clothing.

The counterculture and youth movement of the sixties were not always the

most financially secure members of society, and surplus stores and thrift stores offered an entire wardrobe's worth of discounted clothes.

In the blank canvas of the T-shirt the would-be-activists of the 1960s saw the "medium" waiting to deliver its "message," to paraphrase social scientist and critic Marshall McLuhan. ▪

favor of the establishment" was an approach endorsed by several leaders of the gay movement at the time, and dressing conservatively in public was one way of maintaining that respect. When it came to the question of what defined proper attire, it didn't help that there was already infighting in gay circles with an "us against them" mentality creating rancor: Men favoring leather and jeans were condemning what they called "sweater queens" for appearing too effeminate.

LONG BEFORE THEY openly declared their orientations to the straight world, gay men had a long history of communicating with one another through a codified language of words, phrases and even articles of clothing. Questions of "Is he, or isn't he?" were answered by knowing nods, cleverly worded cultural

references, well-placed fashion accessories and, in rare situations, the flashing of hand gestures. These were meant to send private messages, and were part of a conversation intended solely for those who could crack the code and decipher the clues given. They were not intended as public service announcements. Indiscriminately advertising one's orientation—through clothing or otherwise—would have reaped few benefits beyond the immediate and the obvious with few exceptions. What was there to gain from such a declaration?

But in the sixties, when the youth movement succeeded in grabbing media attention with unconventional modes of dress and strong uncompromising messages, gays and lesbians learned from their assertive examples. Placards that read "Gay is Good" were laid down, and signs reading "Gay Power!" were hoisted instead. With this change in message came the change in delivery. Buttoned-down shirts and well-pressed skirts were tossed off as T-shirts and jeans became part of the new uniform of these burgeoning revolutionaries. Denim was the cloth from which the new counterculture had been cutting its rebellious image since the fifties. Favored first by bikers and then hippies, jeans became symbolic of a generation as well as a way of life.

BUT IT WAS in the humble white T-shirt, the underwear-turned-outerwear, that revolutionaries and outsiders had found their most effective means of social and sartorial protest yet. If a wardrobe could carry one type of message, as was the case with the respectful comportment of the suit and tie, then clothing, and especially a printed T-shirt, could also deliver another kind of message; one of defiance, strength and pride.

AT FIRST IT SEEMED only those involved had taken notice. The riot that took place on the night of June 28, 1969, at the small bar in New York's Greenwich Village known as the Stonewall Inn, was initially seen as such a minor occurrence that even the city's papers all but ignored the incident in the next day's news. The chaos that ensued after an all too familiar business-as-usual raid by the local police resulted in numerous arrests, countless injuries, the ransacking of the Stonewall and ultimately the birth of a movement. But few gays and lesbians outside of New York City were even aware of what had happened that night, or the night after, at 51-53 Christopher Street. In a year's time, though, "The Hairpin Drop Heard Round The World," as one neighborhood resident called

the Stonewall Riots, would be responsible for helping many gays and lesbians shed feelings of shame associated with their orientation. The one-time pariahs were becoming a proud minority, albeit one that was coalescing into a political and social force to be reckoned with.

While the celebration of Christopher Street Liberation Day, as the event marking the first anniversary of the Stonewall Riots was called, had its origins in the residual anger and energy those riots ignited, it was a watershed moment for America's homosexual rights movement. Gays were learning there was power in being vocal and visible.

And visibility as an alternative to the closet had gone from being unthinkable to inevitable.

OCCURRING AS THEY DID in the last year of the 1960s, the nights of resistance that erupted in New York in late June and early July of 1969 were the culmination of decades of harassment. Police raids of gay bars happened with a business-as-usual frequency. ID and clothing checks—to determine proper age and proper attire—were within the letter of the law; the latter stating that persons appearing in public were required to wear a minimum number of gender-specific garments. In bars and clubs

from San Francisco to Los Angeles to Chicago to New York, and at countless points in between, even dancing with a member of the same sex was forbidden and punishable by law.

Gays and lesbians had no protection from the government in their professional or personal lives when it came to discrimination in matters of housing and employment. In fact the military's attempts to root out homosexuals from the armed services during WW II were a prelude to President Eisenhower's Executive Order 10450 which made it legal to terminate the employment of any government workers who were gay. With such a directive coming from the highest branch of the federal government, and with hostilities from local police departments who routinely raided gay bars descending into beatings and brutalities, gays and lesbians who might have attempted to come out were being shoved back into the closet, and pinned behind their doors.

FOR HOMOSEXUALS WHO HAD

come of age during the 1940s and 50s, the events of the summer of 1969 were almost inconceivable. For this generation, caution was the watchword when it came to coming out. Peaceful and orderly protests, like those held by the gay and lesbian

group, the Mattachine Society, were favored over raucous displays. With public opinion of the minority already low at best, hateful at worst, homosexuals chose to present an image that heterosexuals could identify with, if not respect. Sooner or later heterosexuals would have to acknowledge that homosexuals were the same as them. Civil rights for gays and lesbians were inevitable. But as gay politician Harvey Milk would astutely recognize years later when it came to granting equal rights and privileges, power is never given to a minority. Power has to be taken.

Taking power, if not control of their destinies, became a rallying point for the new generation of gays and lesbians coming out at the end of the sixties. And one of the first action items on their agenda was the informal abandoning of many of the tenets that defined the old gay rights guard. Orderly conduct, mild-mannered speech and respectable forms of dress were all viewed as placation devices that, while they might have appeased some heterosexuals, kept the movement stalled. In fact, the reticent sentiment expressed by one gay rights activist who told a post-Stonewall Riots mob, "Rocks through windows don't open doors," was in sharp contrast to the opinions held by

11

many New York homosexuals in the wake of the uprising. At a meeting of the Mattachine Society nearly two weeks after the riots, the call for homosexuals to behave in a manner that would "retain the favor of the Establishment," was met with jeers. A proposed vigil to protest the treatment of homosexuals was greeted with even more vociferous dissent. The days of lighting candles and standing silently were being extinguished. There was a fire burning in the belly of the homosexual community. A sense of urgency, an awareness of "if not now, when?" was stoking the feeling of empowerment. The time for action was here.

THE AIM OF THE ACTIVISTS who were coming together after the Stonewall Riots was to make sure that the days of living in fear of police and public abuse and oppression would become a thing of the past. Looking toward the future, gays were realizing that a new attitude was needed immediately. The days of meek compliance and well-mannered subservience were gone. Those methods, as seen through the eyes of the new activists, weren't working. The Mattachine Society and its spin-off group ONE advocated an approach that was orderly and inoffensive. Even the Mattachine name was adapted from that of an

idiot savant of the Italian theater, a character who was by his very nature unthreatening. The new breed of gay rights reformers aligned themselves with more radical entities. The Black Panthers, for instance, were admired for their determination to take care of their own people without asking for or expecting help from the white establishment. Resistance groups such as the Communist Vietnamese Liberation Front were the inspiration for the Gay Liberation Front, formed by members of the Mattachine Action Committee. In adopting a name with such connotations, a platform for the new group, or at least a modus operandi, was all but laid out.

THE NEW ENERGY rippling through the gay community in the summer of '69 was evident in more than just the new names of homosexual organizations. "Gay Power" replaced "Gay Is Good." The new slogan carried a punch, making the former motto sound timid in comparison. Members of the Mattachine Society were casting off the conservative dress code its founders had previously insisted upon. At a July 4th gay march in Philadelphia barely a week after Stonewall, protestors attending the Annual Reminder, as the event was known, had left their jackets, ties and skirts back in their closets. Jeans and T-shirts

AS A MOTTO FOR homosexual activism the phrase "Lavender Menace" hardly sounded confrontational. It not only poked fun at the McCarthy era's paranoid obsession with Communism's infiltration of America during the 1950s—a plot which the government suspected many homosexuals of advancing—it also had an unthreatening tone that diffused some of the fear or

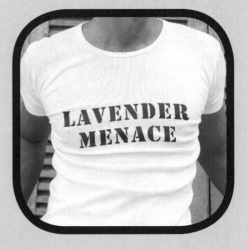

anxiety heterosexuals might have about encountering anyone espousing it. Besides, among some heterosexuals lavender was nearly synonymous with pansy, a derisive term for gays that alluded to their inefficacy and weakness. The term Lavender Menace sounded as vicious or dangerous as Flower Power, a unifying slogan of the pacifistic anti-war movement of the late sixties and early seventies.

But as an attention-getting device the Lavender Menace T-shirt was an unquestionable success. It got noticed, and it got results. When thirty lesbians from the Gay Liberation Front, all wearing Lavender Menace T-shirts, took control of a stage at a meeting of the Congress to Unite Women in May of 1970

the feminist organization was forced to listen. The agenda of the Congress had previously ignored lesbian issues, but after the Lavender Menace action, the organization motioned to add the lesbians' concerns to their platform.

The T-shirts served as a uniform for the women, uniting them in dress as well as in message. There was also a bit of leftover radicalism in the cross-dressing act of wearing what had once been considered menswear. The T-shirt was becoming a unisex article of clothing, an idea that was greeted with some strong opposition from traditionalists.

The Lavender Menace Action, as it was known, proved to the women who donned the shirts that there was power in risk. Wearing your sexual orientation on the proverbial sleeve was one thing, but emblazoning it across your chest was a new kind of provocation—and a new declaration of liberation.

Would such an action have taken place pre-Stonewall? It's hard to determine. What can be said is the events of the summer of 1969 showed homosexuals that when they resorted to other means of protest as a unified group they had a power they hadn't had before. And this empowerment was noticeable. As Beat poet Allen Ginsberg had observed when looking around at the patrons of the Stonewall when it had reopened after the riots, "They've lost that wounded look that fags all had ten years ago." ■

were the attire chosen for the day.

Now liberated from their former behavioral and sartorial confines, the newly galvanized gay groups took to the streets with a new sense of purpose. Many new organizations, like the Gay Liberation Front and its offshoot the Gay Activists Alliance, were staffed by young men and women who believed that simply increasing their visibility didn't guarantee that their struggles were seen, nor did being vocal assure that their voices were heard. Picket signs with quaint slogans were easy to dismiss, since the proximity between the message and the messenger decreased as soon as the person carrying the sign set

it down. A few participants in the first gay pride march even admitted they'd brought their dogs along so they could merely claim to have been walking their pets had anyone questioned what they were doing.

But donning a T-shirt with a provocative phrase emblazoned across the front turned the person wearing the shirt into a walking billboard, creating a new form of social commentary and protest in the process. It also turned them into a potential target. They were not merely wearing their convictions on their sleeves; they were proclaiming their status across their chests.

Being out was difficult enough in the sixties and the previous

16

decades, as the members of the nation's first gay and lesbian rights groups, like the Mattachine Society, the Daughters of Bilitis, and Society for Individual Rights, aka SIR, had learned. Conformity and compliance, they thought, were the keys to integration and ultimately acceptance into—and by—the mainstream. The risks taken by the members of these groups were enormous, coming out at a time when there was no government protection and little public sympathy for their collective plight. The history of the gay rights movement is indebted to their bravery. But by the end of the 1960s the new generation of gay leaders was seeing that the mainstream,

which the Mattachine and others had so cautiously courted, was indifferent at best, hostile at worst. Recent history proved the heterosexual community was likely to allow the issue of homosexual rights to get swept away in the cultural current.

The young army of gay activists looked at the actions of their predecessors and came to the conclusion that the closet door wasn't the only one they would need to break through as the straight world continued to shut them out. And to accomplish this they would need new tactics and new tools.

THE HOMOSEXUAL rights movement had come a long way

17

from the first picket lines to the sit-ins and protest marches that called for gay equality. Unfortunately the path beyond this point was to be littered with disagreements and bitter resentments about how the movement for gay and lesbian rights should proceed. Those who favored a more sedate approach, one that courted heterosexual acceptance, were seen as Uncle Toms (and Aunt Thomasinas), too eager to kowtow to the straight majority in exchange for a minimum of recognition. The new generation of gays and lesbians—including the street kids and drag queens that initiated the resistance at Stonewall—saw the old guard as

being just that, old, and ineffective.

The younger gay activists felt the previous generation had sold out their individuality through compliance only to receive nothing in return for their efforts. Even within groups that favored militant action divisions were appearing. Some members of the GLF, for instance, were in favor of aiding other activist groups that had nothing to do with the advancement of homosexual rights like the Black Panthers. But with so few resources available to advance their own agenda, others in the gay rights movement felt it was best to focus on their own liberation first. It was this difference of opinion that led to the formation of the Gay Activists Alliance (or GAA),

a spin-off of the Gay Liberation Front, in December of 1969.

The GAA's goal from the beginning was to "demand the freedom for expression…through confrontation with and disarmament of all mechanisms which unjustly inhibit" gays and lesbians, according to the preamble of the organization's constitution.

IT WAS FROM the formation of the Gay Activists Alliance that the lambda symbol, one of the most enduring modern symbols of homosexuality, was born. The lambda was the eleventh letter of the Greek alphabet and a symbol that heretofore was used to

represent an energy exchange. In the case of the gay rights movement that energy was the activism used to initiate positive change. It wasn't long before a yellow lambda symbol was splashed across the front of T-shirts that were worn in protest marches as well as the first official simultaneous gay pride celebrations.

THE CHRISTOPHER STREET

Liberation Day in New York City and the Christopher Street Liberation Day West in Los Angeles were scheduled to fall on June 28, 1970, to commemorate the uprisings at the Stonewall Inn the

THE GAY RIGHTS MOVEMENT, as it was being shaped at the end of 1969, had groups and organizations with growing memberships, and as the events of the confrontation at the Stonewall Inn took on a legendary status of their own, the movement even had its own Independence Day.

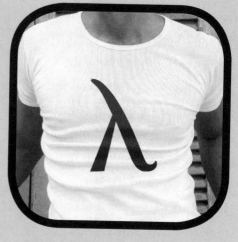

What the movement did not have, however, was a unifying symbol. Gays and lesbians, after all, came in every size, shape and color imaginable, shared no similar physical trait, religion or country of national origin. Unifying such a disparate group under a flag, symbol or icon was proving to be a tough task,

previous summer. A great deal had happened in the national gay community in the year between the riots and the observance of their first anniversary. No longer timidly watching from the sidelines, gays and lesbians began demanding equality. They stormed New York

especially when so many different ideas about the future of gay rights were now being brought to the fore. One organization, the Gay Activists Alliance (or GAA), considered the new energy that was galvanizing gays and lesbians and proposed that the lambda—itself a symbol representing an exchange of energy—become the symbol for the new era of gay liberation. Bright yellow λs were splashed across purple T-shirts as the eleventh letter of the Greek alphabet became symbolic of the way the gay rights movement's energy and activism were initiating positive change.

The goal of the early GAA, according to the preamble of its constitution, was to "demand the freedom of expression…through confrontation…" and by proudly wearing T-shirts with lambdas on the front, gays and lesbians were taking their message of gay pride out of the closet, out of the meeting halls, and into the streets. ■

City government offices to protest laws that discriminated against them. They barged into editorial offices insisting upon fair portrayal by the media. And they interrupted conventions held by those in the mental health field demanding "a dialogue."

HOMOSEXUALS ACROSS the country were standing up and coming out with new assurance. On the last Sunday in June in 1970, gays and lesbians took to the streets in New York and Los Angeles to show their brothers and sisters they no longer had to hide and to show the rest of America they were here to stay. Neither police brutality nor public jeers, not even the threat of violence from homophobic street thugs could force them back into the closet. And in New York, people did indeed take notice. "No one could believe it," the *Village Voice* reported of the public reaction to the literally thousands of homosexuals who'd taken to the streets to participate in the Christopher Street Liberation Day march. "Sunday tourists traded incredulous looks, wondrous faces poked out of air-conditioned cars."

The Christopher Street Liberation Day march was staged to commemorate the events responsible for the new attitude of empowerment in the homosexual rights movement. But for the men and women who'd fought for gay rights for years, even decades, Christopher Street Liberation Day was more than just an anniversary observance of the Stonewall Riots. It also paid tribute to all the brave efforts, the orderly as

well as the rebellious acts that helped usher in an era when gay rights no longer had to be a subject discussed at clandestine meetings. The struggle for those rights could be a source of pride, celebrated in the streets.

I used to haunt these super-seedy Toronto T-shirt stalls [and] I vividly remember the time I added a Morrissey T-shirt and a *Rocky Horror* [*Picture Show*] Tee to the pile. Though neither of these shirts explicitly telegraphed my homosexuality…I felt these Tees described my peers' and my own sexuality much more accurately than any of the more explicit symbols I could've worn.

SCOTT TRELEAVEN

filmmaker, writer, and visual artist
Salivation Army and *Bug Crush*

Mapping a Movement

IT HAD BEEN FIVE YEARS since the kids and queens at Stonewall had fought back against the harassment homosexuals had all but come to expect. Their "we're not gonna take it" attitude was the push the gay rights movement needed to shake it from its polite complacency into course-changing action.

By 1974, gays and lesbians had begun to see signs of a thaw in the country's social climate. An open-arm attitude was far from prevalent, but the hushed tones and harsh voices that once characterized discussions of homosexuality were now being countered by a more reasonable tone.

In the first half of the seventies

public declarations of homosexuality that would have been unthinkable a decade earlier were taking place in the gleam of the political and cultural spotlight. In 1972 the McGovern presidential campaign invited an openly gay speaker to address the Democratic National Convention. Rock stars like David Bowie and Lou Reed toyed with the press about their sexual proclivities, singing about drag queens and male hustlers. T-shirts emblazoned with David Bowie's gender-bending Ziggy Stardust persona raised questions about the wearers' own orientation. Meanwhile Elektra Records' ill-fated out gay rocker Jobriath was far less coy, describing himself in interviews as "a true fairy." In 1973, the same year Jobriath's semi-nude form crawled across a billboard over Times Square, PBS was introducing Middle America to the fully clothed, but no less provocative Lance Loud, the openly gay son of the Loud family featured in the public television series *An American Family*.

Homosexuals were being seen and heard, whether on the radio, on TV or on the political stage in the early 1970s. But for all of the progress that such visibility helped achieve in the first half of the decade, rights advocates remained divided as to the best way to capitalize on that attention now that society seemed to be taking notice. Unity would

be essential, especially since the second half of the seventies was to be marked by roadblocks and setbacks as opponents to gay rights effectively used the media as a platform to deliver their messages as well.

THE NEW POSTURE and expression Ginsberg had observed post-Stonewall was that of a people empowered. And as the gay rights movement moved into the seventies the disagreements from the past about how best to press on for equality would continue. The infighting that had caused rifts in stalwart groups like the Mattachine Society and SIR (the early Society for Individual Rights)

also plagued upstarts like the Gay Liberation Front and the lambda-flying Gay Activists Alliance.

AS GAYS AND LESBIANS formed new groups and alliances to address the issue of securing their rights, an awareness of their potential political power began to grow. Members of the Society for Individual Rights were in awe of their own influence in 1969 when Dianne Feinstein acknowledged her election to the San Francisco city supervisors' board was due in part to the votes she received from the gay community. Now, in 1972, barely three years later, gay rights groups had even more substantial proof that their

THE POWER OF THE T-SHIRT as

political statement became stronger in the early 1970s. The shirt's blunt declaration, Gay Vote, didn't require further graphics. It immediately conveyed the point of view of the person wearing it, and identified them as homosexual—or as someone who supported gays and lesbians, which was just as potentially controversial. T-

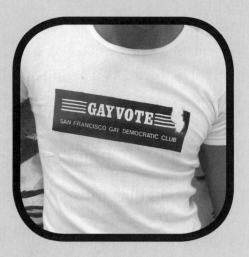

shirts that displayed an allegiance to other gay political groups, like the Coalition for Human Rights, required a certain cultural savvy from the observer in order to be understood. Even the groundbreaking lambda symbol T-shirts could have been

influence was increasing when the presidential campaign of George McGovern invited a member of the Alice B. Toklas Memorial Democratic Club to speak at the Democratic National Convention in 1972.

The Toklas organization was formed from the Society for

misinterpreted, the person wearing it being seen as a chemist or physicist given the Greek letter's formulaic status. But there was no mistaking that the wearer of the Gay Vote shirt supported gay and lesbians rights and endorsed candidates who did the same at the polls.

The words "Gay Vote" were doubly powerful. They described a person as well as an action, the latter being protected by The U.S. Constitution. The voting power of gays was making a difference in local elections in cities like San Francisco since the late 1960s. By 1972, a member of the Alice B. Toklas Gay Democratic Club spoke at the Democratic Convention as presidential candidate George McGovern's platform included, for the first time in American history, gay and lesbian rights issues. Despite any differences of opinion among those wearing the shirts, all of the gay vote or gay political group T-shirts carried a powerful message: "I matter. I count. And I can make a difference." ∎

Individual Rights' political arm, and became one of several gay Democratic clubs in San Francisco in the early seventies. With the city having such a large concentration of homosexuals, savvy politicians were beginning to see an untapped opportunity; as a minority it seemed that gays

were a fairly solid voting bloc. If homosexuals could be counted on to vote in their best interests, then any candidate who wooed that vote would have a strong turnout at the polls. Homosexual groups also networked through gay bars, registering gays to vote as Democrats. According to Randy Shilts' book *The Mayor of Castro Street*, signatures obtained in this manner by the Toklas club's Jim Foster and his volunteers helped to secure over 33 percent of the necessary names required, placing presidential candidate Senator George McGovern on the California primary election ballot. McGovern had a "seven-point gay rights plank that satisfied virtually every demand the fledgling gay movement was making" in the early 1970s, Shilts wrote. Endorsing him as a candidate seemed imperative to advancing the move for homosexual equality.

AS THEY WERE BEING welcomed into the larger political arena, gays and lesbians were learning that they no longer had to stage sit-ins or throw bricks through windows to be heard. Candidates needed money to fill their war chests. Without having families to support, many homosexual men had, on average, a larger disposable income than the rest of the population, and gays found that formerly indifferent heterosexuals were

willing to take them seriously when they threw around their cash.

But again just as earlier gay and lesbian organizations became bitterly divided over how to position their cause to the public, so some homosexual political clubs were soon torn apart when it came time to endorse candidates for office. At issue, and causing the new rifts were races in which support from the gay clubs was thrown behind moderate candidates in lieu of more liberal straight or even gay candidates. The approach of gay Democratic clubs like Alice B. Toklas was similar to the one that had guided the actions of groups like The Mattachine Society; earn approval through appeasement but

whatever you do, don't rock the boat.

Boat rocking was just the thing that needed to be done, though, according to gays and lesbians who didn't want to misspend the political capital they were now earning. When a Castro Street merchant by the name of Harvey Milk first discussed running for the San Francisco supervisors' board in the early seventies, he was told by the leader of the Toklas club "It's not time yet for a gay supervisor." But before the decade would reach the midway point two politicians received national attention for admitting to their sexual orientation; Elaine Noble from the Massachusetts House of Representatives and Allan

Spear from the Minnesota State Senate. This was a major turning point for gay visibility: Openly gay officials could be elected to power, and could stay in power once they came out. The tide seemed to be changing. Energized by their growing political clout, gays and lesbians began lobbying elected officials and candidates to support the passing of laws that moved homosexuals towards having the same rights as heterosexuals in America.

BY 1975 gay civil rights bills had been passed in nearly a dozen U.S. cities. The government repealed its ban on hiring homosexuals for the U.S. Civil Service Commission that same year. (For Frank Kameny and other members of the original Washington, D.C. chapter of the Mattachine Society who lost their jobs as part of the government's post-war witch hunt of homosexuals, this victory was a long time in coming. Kameny had been dismissed from his job as an astronomer with the government in the late 1950s and had lost a battle to have his job reinstated in 1961 when the Supreme Court refused to hear his case.)

Also in 1975, for those Americans who thought gays and lesbians were a minority relegated to arty and urban environments, far removed from their sphere of contact or even interest, a major revelation was about

to open their eyes. In an interview with the *Washington Star* NFL player Dave Kopay spoke openly about his homosexuality. Kopay became the first major American athlete to come out of the closet, and in doing so turned stereotypes upside down. Americans were forced to confront their own preconceived notions of what a gay man was. Two years after his announcement, the memoir, *The David Kopay Story: An Extraordinary Self-Revelation* became a best seller.

It appeared that a cultural, if not political, breakthrough was on the event horizon for the homosexual community. But just because Americans were willing to shell out cash to read about a gay football player didn't mean they were necessarily ready to employ gays and lesbians as teachers in schools.

IN 1977, the year Kopay's book was released, homosexual visibility was certainly at an all time high. The fall television lineup for the '77 season included the ABC soap opera parody, *Soap*, featuring the gay character Jodie (played by up-and-coming straight comedian Billy Crystal.) Top 40 radio stations were introducing listeners to a lyrically quirky-but-catchy disco track entitled "Macho Man," sung by a group of strangely dressed men who called themselves the Village People. Music was playing a big part of the social lives of gay men

with disco providing the soundtrack in bars and clubs that could safely bill themselves as gay bars without risking regular harassment by the police. Punk rock was creating a different sort of social atmosphere, one that was more inclusive of gays and lesbians than its mainstream arena rock counterpart. (Despite the growing success of Queen, Freddie Mercury's homosexuality was not something openly discussed in, or portrayed by the media at the time.)

On the political frontlines, the administration of President Jimmy Carter became the first to welcome a delegation of gays and lesbians into the White House. And that same year, nineteen states in the U.S. had repealed laws that made engaging in homosexual acts illegal. In some municipalities, local governments were going a step further, granting gays civil rights by proposing ordinances which protected gays and lesbians from discrimination in issues of housing, employment and public accommodations.

This felt like real progress. A significant cultural shift seemed to be taking place. But just as momentum was building that would have propelled the gay rights movement forward, a powerful backlash was beginning to swell that would turn the tide of public opinion. In Dade County, Florida, where an ordinance had been passed protecting gays from

employment discrimination, counter efforts to overturn the court ruling by anti-gay factions were frantically underway. Leading the charge was Anita Bryant, former Miss America contestant, quasi-entertainer and Florida Orange Juice spokesperson. Bryant's beef with the Dade County judicial decision focused on the law's allowance of gays and lesbians to hold teaching positions in public schools. Rallying voters with a "Save Our Children" petition drive, and warning parents of the "recruitment" tactics homosexual teachers would no doubt use to seduce their students, Bryant secured enough signatures to bring the Dade County gay rights bill back to a vote. When it came time to vote, the ordinance was revoked by a two-to-one margin.

BRYANT, NO STRANGER to courting interest, had clearly won over members of the media as well. *Time* praised her on the night of the election as the "woman of the hour," with a "dazzling smile." At a press conference in Miami Beach she declared a victory for the "normal majority" who had voted to protect "the cultural values of men" by endorsing "the laws of God." (Just as it swooned over Bryant, the nation's newsmagazine would be equally effusive in its revilement of gays: Nearly two months after the Dade County vote, *Time* would run an

THE GAY RIGHTS movement had come a long way in a few short years, and so had its way of publicly identifying. While there is nothing explicitly gay about the Anita Kisses Oranges shirt, its message was hard to misinterpret in the summer of 1977. And it left no doubts as to what side of the brewing cultural controversy that Ms. Bryant was stirring—should gays and lesbians be allowed to teach

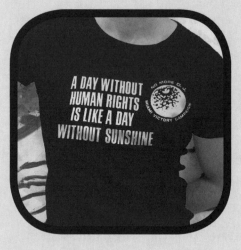

school children?—the person wearing the shirt was aligned with.

The homosexual community had been repeatedly attacked for decades by numerous voices, but Bryant's use of the media pulpit empowered gays and lesbians to fight fire with fire. She may have the distinction of being the first anti-gay villain immortalized on a T-shirt.

Bryant, the object of the shirt's ridicule, had provided magazines, newspapers and newscasts across the nation with plenty of fodder as she made comments about "the normal majority" and "the laws of God" during her anti-gay crusade in Dade County. The media seemed smitten by the former Miss America's one-

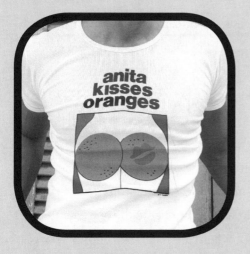

time celebrity status and chronicled her moves, her musings and even her appearance. *Time* magazine used words like "dazzling" and "resplendent" when describing Bryant's dress even as she spouted her divisive rhetoric.

The oranges on the T-shirt, positioned to resemble a woman's backside, mocked the shapely Bryant's role as a spokesperson for Florida Orange Juice. And its slogan was the protestors' way of telling their assailant to mind her own business. Other T-shirts were more to the point about silencing Bryant as they carried the image of the former beauty queen with an orange stuffed in her mouth. The "A Day Without Human Rights is Like a Day Without Sunshine" T-shirt, produced by the Miami Victory Campaign group in support of gay employment rights, riffed on the slogan Bryant made famous in her television commercials for her sponsor. "Human Rights" was the term often used when politicking for gay rights, especially when its advocates were accused of asking for "special rights" rather than "equal rights."

Since gays and lesbians encountered such significant opposition in the recall election in Florida that Bryant had initiated, they realized that if they couldn't make a dent with poll numbers they could certainly have an effect on retail numbers. A boycott of Florida Orange Juice products was launched and "No More O.J." was emblazoned across T-shirts.

Bryant's fire eventually faded but not before it spread, heating up discussions and arguments about gay rights in other areas of the country. Politicians across the nation seized the opportunity to divide communities in rancorous debate over the issue of gay and lesbian teachers. In Oklahoma a bill similar to the one championed by Bryant was approved, and in California, where the issue of homosexual rights had made real progress since the late sixties, California State Senator John Briggs

article about the retaliatory actions of some homosexuals in New York with the headline "The Gay Goons.")

Gays across the country fought back with demonstrations in various cities. With simultaneous protests in Atlanta, Chicago, Los Angeles, New York, San Diego, San Francisco and Seattle, the gay community had organized the largest nationwide demonstration since activists had taken to the streets to protest the

unveiled Proposition 6, an initiative that would bar homosexuals from teaching in the classroom. Gay activists printed T-shirts bearing a big red apple and the plea "Support Our Gay Teachers and Gay School Workers" for wearing at rallies and marches. The shirt's graphic design was remarkable if only because of its casual juxtaposition of the word "gay" along with the time-honored symbol of the appreciative, if not slightly cloying, student—the apple for the teacher.

Briggs would go on to lose where Bryant had triumphed, but the biggest win to come out of the summer months of 1977 belonged to the gay and lesbian community for coming together to fight a common enemy.

The gay rights movement had learned that if the opposition was well organized and loud, they would have to make their voices that much louder. ∎

Vietnam War. Provocative T-shirts were proudly worn as a way to strike back at Bryant. "Anita Kisses Oranges" was the protestors' polite way of telling Ms. Bryant to mind her own business. Other T-shirts carried the antagonist's image with an orange stuffed into her mouth, while shirts printed for the Miami Victory Campaign borrowed from Bryant's orange juice endorsement: "A Day Without Human Rights Is Like A Day

Without Sunshine," ran across the front of the shirt with the tag "No More O.J." To that end, boycotts of Florida Orange Juice were enacted.

Calling the Dade County situation "the Selma" of the gay rights movement, leaders of the gay community chose to see the positive side of the ordinance's overturning: The vote, the publicity it generated, and the corresponding anti-gay sentiment synthesized and energized the gay community into a more cohesive unit than it had been. Still, some like Air Force Sergeant Leonard Matlovich—a Vietnam War hero and now a hero of the gay rights movement because of his self-initiated dishonorable discharge from the military—cautioned that Bryant's charge was just the beginning. "Stormy times are ahead," he predicted, and he was right.

The "flurry of firings," as Bruce Voeller, then the co-executive director of the (then named) National Gay Task Force called the dismissal of gay and lesbian employees in Dade County, was just the beginning. Empowered by Bryant's win, politicians across the country saw an opportunity to advance their conservative agendas. Oklahoma's state legislature approved a resolution similar to the one Bryant brought to a vote in her Florida County. In California, State Senator John Briggs cautioned his constituents that the "San Francisco

influence" on their state's political future was endangering their children by allowing them to be exposed to gay and lesbian teachers and school employees. Proposition 6, as packaged by Briggs, would remove gay and lesbian educators from the classroom. Gay activists printed T-shirts bearing a big red apple and the plea "Support Our Gay Teachers and Gay School Workers" for wearing at rallies and marches.

BRIGGS WOULD GO ON to lose where Bryant had triumphed, but the biggest win to come out of the summer months of 1977 belonged to the gay and lesbian community for coming together to fight their common enemy. Activist groups like the Coalition for Human Rights were formed in reaction to the Briggs' Initiative. The gay rights movement had learned that if their opposition was well organized and loud, they would have to make their voices that much louder.

ONE THING THAT ACTIVISTS on both sides of the Dade County issue agreed upon was that the anger of the community, as expressed by some gays who assumed an increasingly combative stance, could lead to a backlash by straight society that could push the homosexual rights movement back to square one. This had long been a concern of

GAYS, OR LESBIANS for that matter, didn't need to wear "Anite kisses oranges" on their chests to make a statement in the latter half of the 1970s. The very simple printing of the words "gay pride week '77" on a T-shirt was direct, and to a degree shocking enough. That the words "gay" and "pride" would ever be used together to describe a one-day event, let alone a weeklong

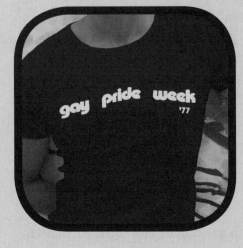

celebration, was unthinkable prior to the seventies. And to wear such a shirt in public

gay activists all the way back to the first Mattachine assemblies. Gays and lesbians who favored a more reserved approach to securing rights frowned upon the tactic of pushing for or asking for too much too

soon. Even though the call for equal rights in Dade County was tame, the gay community couldn't help but wonder if the reports of violent gay-bashing incidents that occurred in the immediate aftermath of the

to commemorate the event would have, at the very least, incited controversy.

The significance of the 1977 "gay pride week '77" shirt in the wake of the Anita Bryant media storm and the Dade County vote was the level of coverage being given to gay pride events in the press. It was reported that "gay leaders…asked for—and, almost without exception, got—restraint in clothes and behavior" on the part of parade participants in San Francisco. "Previous [gatherings] had been marked by lots of exhibitionism."

It was a sign of the changing attitudes and changing times that these commemorative shirts were even available, despite the fact that wearing them instead of something more provocative might have been seen as a step backward to the days when a staid dress code was favored by the Mattachine Society. ∎

Florida campaign were motivated by Bryant's rhetoric. In her speeches to voters she made it clear that she saw homosexuals as sinners deserving of God's wrath. She invoked the tactics of a holy war, citing the Bible, "God's law" and "morality" by calling gays "sinners." She warned Cuban immigrants that Miami was on the verge of becoming "another Sodom and Gomorrah," adding that it would "break [her] heart…if [the

WHEN ENGLAND'S PUNK ROCK and fashion impresarios Malcolm McLaren and Vivienne Westwood were looking for controversial images to emblazon the fronts of their new line of T-shirts, they knew exactly where to turn—the gay men's clothing shops in San Francisco's Castro District. San Francisco was the West Coast hub, the destination city for gays in the

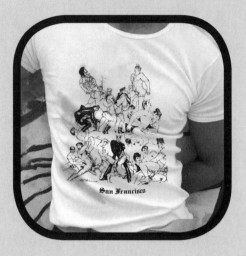

1970s, just as New York City was its East Coast counterpart. The freedom and comfortableness of gay life in The Castro neighborhood of San Francisco was not only evidenced by the sheer numbers of the district's gay residents but also by the openness, detractors would say brazenness, with which they made their orientation known. Gays felt safe expressing themselves on the streets of The Castro in a way that they wouldn't have dared a decade earlier, there or elsewhere. Shops displayed S&M gear, leatherwear and provocative T-shirts in their storefronts. The T-shirts often depicted lewd caricatures of cartoon

characters like Mickey Mouse, or nude, muscular males drawn in the style of Tom of Finland, engaging in the kind of sexual acts that, according to many state law books, could land a person in jail. Though a portion of the homosexual community would disagree, shirts bearing this type of imagery were symbolic of the growing social confidence gay men had when it came to being public about what they did in private.

The "After Tom of Finland" T-shirt, which depicted an ecstatic orgy of muscle men in and out of uniform, not to mention in and out of various sexual positions, and the Tom of Finland T-shirt, as remade by Vivienne Westwood, pushed the boundaries of what was acceptable public attire: One patron of Westwood's shop was arrested for "offending public decency" while wearing the T-shirt. But the shirt also illuminated the bond between "punk" and the gay movement. Both had an unyielding take-me-as-I-am defiance and saw the establishment as their enemy. The appropriation of the sexually explicit imagery of the gay artist known as Tom of Finland by a heterosexual fashion designer showed that the gay movement was becoming a viable cultural force. ∎

Cubans] would have to leave again."

For their part, gays likened Bryant to world leaders who had committed their own form of genocide. Protestors in a San Francisco march carried posters displaying the faces of Idi Amin, Adolf Hitler, Joseph Stalin and Anita Bryant while signs reading "Save Our Human Rights" were hoisted in the air beside them.

IN THE WEEKS that followed the Dade County referendum the debate within the homosexual community addressed the semantics of "gay rights" versus "human rights." Maybe the call for gay rights sounded too much like "special rights," argued one side.

The topic had one sticking point that even gay activists conceded was making the push for equality a hard sell—and it was the sexual aspect of "homosexual." There was no denying that what made a homosexual a homosexual was their innate orientation to be attracted, sexually and romantically, to members of the same sex. The idea of giving consenting adults the right to express their intimacy in that way was asking too much of some heterosexuals. Because this was such a striking disparity for some straights to reconcile, gay moderates chose to emphasize similarities with a "we're-just-like-you" approach to garner acceptance.

WHOM TO ENTRUST the political handling of gay rights, outside of the gay community, continued to be a divisive issue among gays and lesbians. Even liberal minded heterosexuals were eyed warily. Some gays felt used by straight candidates who'd courted their vote only to abandon these same constituents once in office. Others felt that backing a gay candidate was political suicide for the movement as a whole. Nowhere else was this dynamic debate polarizing gays and lesbians more than in the San Francisco enclave known as the Castro. At the center of this dispute was Harvey Milk, the owner of a small camera shop in what was fast becoming the gayest neighborhood in the world. A controversial figure even among those who supported him, Milk entered the San Francisco political scene in the early 70s and received a less than warm welcome. Straight opponents saw him as an easy target, a pony-tailed hippie who was gay, while gay leaders saw in his brash comments and unkempt appearance their worst nightmare. In his early political career Harvey Milk was, as Randy Shilts observed in *The Mayor of Castro Street*, "running against Harvey Milk."

As Milk honed his personal grooming style by dressing the part of a politician, people began to take Milk seriously. Resistance hardly disappeared, though. Some of the

biggest roadblocks on his path to winning political office were put in place by members of the gay power elite who thought a gay politician, especially one as fiery as Milk, would alienate more people than he would engage. The San Francisco city officials were just as unwelcoming of Milk's aspirations for public office. Milk saw all of this as an opportunity to position himself as the underdog the system preferred to keep in his place: T-shirts that read "Harvey Milk vs. The Machine" were printed and widely distributed.

T-shirts became a powerful campaign tool for Milk. Sightings of San Francisco firemen riding on the back of their engines wearing shirts that read "Make Mine Milk" were better publicity than any photo op that could've been staged. It took just as much fortitude for straight men to publicly proclaim such an affiliation across their chests as it took gays to do the same.

After years of unsuccessful bids for various city posts, Harvey Milk was voted onto the San Francisco Board of Supervisors in 1977. San Francisco, the gayest city in the west, finally had elected an out homosexual to its local government.

SAN FRANCISCO WAS the West Coast hub, the destination city for gays in the 1970s with New York City being its East Coast counterpart. Gays

felt safe expressing themselves on the streets of The Castro neighborhood in a way that they wouldn't have dared a decade earlier, there or elsewhere. It was this bold in-your-face posturing among some members of the gay community that made San Francisco residents like Dan White steam. White and other long-time denizens of the city saw the incoming gays as immoral invaders who threatened standards of decency with their flagrant displays of affection and their inappropriate attire. (The likelihood of the latter occurring was considered enough of an issue that in the wake of the Dade County vote in the summer of 1977, *Time* had reported that "gay leaders…asked for—and, almost without exception, got—restraint in clothes and behavior" on the part of parade participants in San Francisco. "Previous [gatherings] had been marked by lots of exhibitionism," the magazine continued.)

The call for moderation, in their own town, smacked a little of the uniform code previously enforced upon Mattachine picketers. But the fear of a backlash against gays, especially now that the issue of homosexual rights was openly debated, was an increasing concern. Reports of a San Francisco man murdered by a knife-wielding assailant who repeatedly screamed, "Faggot!" had shaken the city.

That the attack came just a week after Orange Tuesday, as the Dade County vote on employment rights was dubbed, confirmed for some homosexuals and heterosexuals alike that Bryant's rhetoric had incited the violence they'd feared.

Before the decade would end another murder would cause San Francisco's residents to question if their efforts to gain rights would ever guarantee security.

ON THE MORNING OF November 27, 1978, former San Francisco City Supervisor Dan White walked into San Francisco's City Hall, entered the office of Mayor George Moscone and opened fire with his revolver.

The Mayor died instantly. White then reloaded his weapon, walked to the office of Supervisor Harvey Milk and fired several bullets into his body, including one shot, point blank, into the back of Milk's head.

The murders threw the city into a tumultuous state. As San Francisco's first openly gay elected official, Milk was responsible for helping to change the gay community's relationship with the rest of the city. Milk had given gays and lesbians across the country a much-needed boost of self-esteem. While other gay leaders advocated a reticent yet grateful posture for the few displays of tolerance the establishment might enact, Milk rallied the community by reminding

them they should never settle for anything less than equal rights. And when his adversaries, sometimes within his own community, refused to yield, Milk energized his followers by declaring, "You're never given power—you have to take it!"

White's other victim, Mayor Moscone had been, considering the times, the most gay-friendly politician the city had ever seen. He was the first mayor to respect gays and lesbians as valued constituents, earning their votes as well as their trust.

The deaths of Milk and Moscone were decried as assassinations; the grief-stricken community considered them martyrs.

In the months after the Milk and Moscone slayings the portrayal in the courtroom of the gunman, Dan White, as a disgruntled city employee led San Franciscans to believe they were dealing with the actions, and the hatred, of one man. But when White was charged with manslaughter rather than first degree murder, the city's gay community felt they were once again dealing with a collective, and bigoted, mindset.

Despite the seeming calculations on White's part—leaving his home with a gun, climbing into City Hall through a rear window so as not to set off the building's metal detector—jurors failed to see any premeditation in his actions on the day of the murders. To San Francisco's

THE DAN WHITE Legal Defense Fund T-shirt was originally made as a fund-raiser to help cover the legal fees for the accused in his murder trial. Sold by the San Francisco Police Department, the T-shirt's message conveyed more than just financial support on behalf of its namesake (who had been out of work since being arrested for shooting Harvey Milk and San Francisco mayor

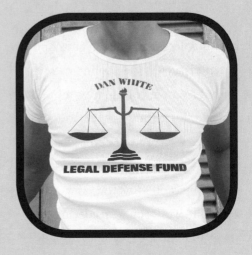

George Moscone). Like the "Free Dan White!" bumper stickers that appeared on the city's streets during the trial, the Dan White Legal Defense Fund shirt fell barely short of endorsing White's actions. It was clear that those who conceptualized, printed, sold, bought and/or wore the shirts believed that Dan

homosexuals and their supporters, the jury's verdict all but condoned White's behavior, and placed the blame on Milk and Moscone.

A CANDLELIGHT VIGIL numbering 40,000 mourners congregated in front of San Francisco City Hall on the night of Milk's and Moscone's

White was not in the wrong for aiming a gun at Moscone and Milk and firing several shots, including one bullet into the back of the fallen Milk's head.

As the existence of the T-shirt would suggest, White had plenty of supporters in the wake of the shootings. Many in the San Francisco police department saw him as a champion of their cause. They could sympathize with his predicaments; from his call to clean up San Francisco which led him to run for the city's supervisory board in the first place, to his reason for resigning due to the position's low pay, to the anger that led him to shoot Moscone and Milk when he petitioned the mayor to reinstate his job. The city's police understood Dan White, and they wasted little time coming to his aid.

Just as wearing a "gay pride week" T-shirt in 1977 was a declaration of allegiance to something larger than the orientation of the person wearing it, the individual wearing the Dan White Legal Defense Fund shirt in 1979 assumed the majority of public sentiment would be in agreement with, or at least tolerant of, its message. ∎

murders. The expression of sorrow, which overwhelmed even some of Milk' most ardent supporters, was testament to the reach of the two politicians' popularity as well as the depths of the community's grief.

The solemn gathering that mourned Harvey Milk and George

Moscone's deaths was in sharp and shocking contrast to the assemblage that would amass in the wake of their killer's verdict. On the night of May 21, 1979, incensed gays and lesbians stormed the city's streets before finally converging in front of City Hall. Rocks were thrown, windows were smashed and the building was literally torn apart as outraged activists pulled down iron grates from the structure's façade and turned them into battering rams. Black and white police cruisers were set on fire and the flames flickered eerily across the melee. The San Francisco Police Department, notorious for roughing up the normally kow-towing gays in unwarranted attacks in the Castro, was stunned by the violent menace of the crowd. Chants of "Kill Dan White! Kill Dan White!" rose into the night along with the flames from the car fires.

IF A JURY IS supposed to reflect one's peers, then it would seem Dan White had plenty of supporters inside and outside the courtroom. Many in the police department saw him as a champion of their cause. A former policeman himself, the one-time civil servant was a symbol of what the new gay rights movement was threatening to dismantle. White was an Irish-Catholic family man who spoke of the need to restore San Francisco's "values." He was annoyed that the

exodus of gays and lesbians from other parts of the country into the Castro neighborhood was resulting in the displacement of families like his own: The Castro was in a section of town where generations of Irish immigrants had settled.

Despite the city's large homosexual population the SFPD, like its counterparts in New York or other major metropolitan areas, had been accustomed to treating gays like criminals for decades and the relationship wasn't about to change anytime soon. In the eyes of the San Francisco police, White was one of their own and they rallied to his aid. Members of the SFPD sold bumper stickers that proclaimed,

"Free Dan White," and T-shirts that supported the "Dan White Legal Defense Fund" to help raise money for the suspected murderer.

In the months leading up to the verdict in Dan White's trial the city and the nation's gay community grew anxious for the outcome. The gay rights movement saw Milk's murder as an assassination on a par with the killing of civil rights leader Martin Luther King, Jr. But there appeared to be few public sympathizers rallying to the gays' cause, as there had been with the Proposition 6 vote earlier in the seventies. Even Mayor Moscone's appointed successor Dianne Feinstein was distancing herself and her career from the gay voters who had helped

JUST AS THEY HAD WORN their anger at Anita Bryant on their chests, gays likewise voiced their discontent with Dianne Feinstein, the appointed successor to San Francisco's mayoral post in the wake of Moscone's death. As her political star rose, Feinstein began distancing herself and her career from the gay voters who had helped elect her to the San Francisco

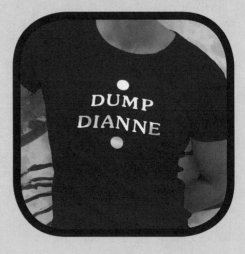

Board of City Supervisors nearly a decade earlier. Feinstein's position as San

elect her to the San Francisco Board of City Supervisors nearly a decade earlier. In fact, Feinstein had been supportive of reinstating Dan White after his resignation. This was seen as a particularly pointed betrayal to gays since White had a reputation for placing the deciding anti-gay vote when reviewing issues before the city's Board of Supervisors.

Feinstein's position as San Francisco's first female mayor cast

Francisco's first female mayor cast her in the public spotlight more than ever after Moscone's death, especially given the circumstances through which she came to office. The press was turning her into a political icon, but in straddling the line between placating future voters and not squashing her senatorial aspirations, Feinstein forgot the voter base which had helped her political star rise. In an interview with *Ladies Home Journal* Feinstein accused the San Francisco gay community of "imposing [its lifestyle] on others," adding that the "rights of an individual to live as he or she chooses can become offensive."

The disappointed community voiced their dismay. "Dump Dianne" was chanted in streets, printed on T-shirts and painted on posters. ▪

her in the public spotlight more than ever after Moscone's death, especially given the circumstances through which she came to office.

With Milk and Moscone gone, the city's homosexuals were already fearful that their future concerns would go unaddressed. Feinstein's comments didn't alleviate their anxiety. She further strained relations when she betrayed Moscone's promise to appoint a gay police commissioner,

a gesture that would have hopefully eliminated police brutality in gay bar raids. The disillusioned community voiced their dismay. "Dump Dianne" was chanted in streets, printed on T-shirts and painted on posters in the demonstrations following the White verdict.

THE FEELING AMONG ACTIVISTS

that Milk's lifework and untimely death were all in vain was realized on Monday, May 21, 1979 when the predominantly white, exclusively heterosexual jury deciding Dan White's fate found him guilty of two counts of voluntary manslaughter. The maximum penalty, with the requisite "time off for good behavior" meant White could serve as few as five years in prison for ending the lives of two human beings.

Dan White got away with murder that day, and that night San Francisco burned.

While Harvey Milk's tactics for advancing the gay rights movement's cause had been one with which many activists and politicians had often disagreed, others refused to stray emotionally from the community's stance regarding the eruption of violence six months after his death. Their message, printed on T-shirts bearing the image of the burning police cars, defiantly said it all: "No Apologies. Ever."

MAY 22ND, THE DAY after the White Night Riots, as the demonstrations of May 21st were to become known, would have been Harvey Milk's 49th birthday. A celebration in front of the Castro Theatre had already been planned. But in the aftermath of the events the night before, T-shirts had been hastily printed and distributed to the crowds that had come to commemorate the anniversary of the fallen leader's birth. The simple phrase "PLEASE—No Violence" was written across the shirt's front.

JUST A LITTLE MORE than a month after the White Night Riots, the tenth anniversary of the Stonewall Riots was observed. The original one-day event that had commemorated Stonewall—The Christopher Street Liberation Day in June of 1970—had grown into a weeklong celebration in the ensuing years. Most metropolitan areas in the United States, and even abroad, were hosting events now billed as Gay Freedom or simply Gay Pride.

With the 1970s coming to a close the homosexual community looked back on a ten-year period book-ended by explosive events. The Stonewall melee was the beginning of the fire, and the White Night Riots were the inferno. The gay community in the United States had grown weary of the bullying. It was time to fight back.

ON THE NIGHT OF May 21, 1979, hours after Dan White had been convicted of manslaughter, rather than murder, in the shooting death of Harvey Milk, incensed gays and lesbians stormed the streets of San Francisco, a riot mob in the making, their anger finally erupting at City Hall. Rocks were thrown, windows were smashed and the building was literally

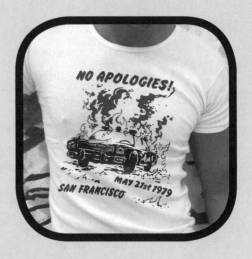

torn apart as outraged activists pulled down iron grates from the structure's façade and turned them into battering rams. Black and white police cruisers were set on fire and the flames flickered eerily across the melee. The San Francisco Police Department, notorious for roughing up the normally kow-towing gays in unwarranted attacks in the Castro, was stunned by the violent menace of the crowd. Chants of "Kill Dan White! Kill Dan White!" rose into the night along with the flames from the car fires.

In the aftermath of the riots over sixty police officers and nearly one hundred gays were hospitalized with injuries. A dozen police cars had been set ablaze. The image of those torched vehicles, set on fire by the individuals they'd often been used to track down, harass and cart off to jail, became iconic. "No Apologies! Ever! May 21, 1979," was the fiery slogan screened over the burning cruiser's image. The shirts were worn proudly in the gay community in the days and weeks following the White Night Riots, as the events of May 21st were now being called. Other shirts used the same image of the burning police cruisers and broadcast an equally strong message: The "Fight Back!" T-shirts that commemorated Stonewall and the San Francisco City Hall riots were more incendiary, so to speak, than the "No Apologies" shirts. The former shirts were defiant, but the latter went beyond merely refusing to assume any culpability. "Fight Back" carried a challenge both to the perpetrators of the mindset that allowed Dan White to get away with murder as well as to members of the homosexual community. Stand up for yourself, it said, or, to recall the words of the fallen Harvey Milk, "You're never given power, you have to take it!" ∎

Through the second half of the seventies, whether it was the Dade County vote or California's Briggs-driven Proposition 6 or Seattle Washington's Initiative 13, homosexuals activists were facing fight after fight to protect or secure their rights. Just as the younger activists took their cues in the sixties from the counterculture movement railing against the war and racial discrimination, those in the seventies became streetwise from watching and listening, in this case, to the opposition. If Bryant and Briggs were winning votes by focusing on homosexuals' sex lives, then the gay activists would play the other side of the same card by emphasizing a person's right to privacy. As the overturning of long-held sodomy laws were showing, Americans might not like the idea of what homosexuals did behind closed doors but what consenting adults chose to do was their business. Besides, opening one door meant that the law could in effect open every door.

The gay rights movement took comfort and found hope in even the smallest victories. The 1970s seemed to hold so much promise for the community, yet the assassination of Harvey Milk, coming after the tough and highly publicized bout to prevent employment discrimination against homosexuals in Dade County, Florida, stirred up feelings

of disillusionment among those who had fought for equality.

THERE WAS CERTAINLY more public dialogue about gay issues ten years after Stonewall but the anti-gay sentiment was hardly erased. Anti-gay words like "fag" or "faggot" were still used without any concession that they might be personally or socially offensive, let alone politically incorrect. A resentment against the few inroads homosexuals had made into the pop culture, like the popularity of disco music for instance, was met with open hostility, even if the motivation for that anger was couched. It was difficult not to interpret the vehemence with which baseball fans took part in the "Disco Demolition" event at Chicago's Comiskey Park in July of 1979 as a thinly veiled demonstration of racial and homophobic violence. The "Disco Sucks" T-shirt became hugely popular, a cultural touchstone of the last summer of the seventies, sold in record shops, head shops and boardwalk venues alike. As a term of derogation the connotation of "sucks" had not yet become the excusable catchall in the vernacular that it would years later. As an insult, "You suck," as expressed in the late seventies, was akin to equating the recipient with the same disgust that was harbored and expressed towards acts of gay sex.

The subject of homosexuality, same sex sex, continued to rankle some members of the public, and was one reason why the gay rights community repeatedly met with resistance. Despite the appeal on the part of activists that they weren't looking for special rights—just the same rights enjoyed by heterosexuals—there was still an otherness associated with gays and lesbians as perceived by the general public. Media portrayals of stereotypes like the flamboyant and self-loathing gay men of The Boys in the Band or the sadomasochists in the 1980 film Cruising didn't help to change that perception. (An interesting side note: The Exorcist director, William Friedkin—who knew a thing or two about shocking people—directed both Boys in the Band and Cruising.)

AS THE 1970S came to a close, despite any disagreements about how to move their agenda forward, there was one action that all advocates of gay rights concurred: Visibility remained key. As a result, the call to come out of the closet grew louder. In October of 1979 approximately one hundred thousand gays and lesbians marched on Washington, D.C. to demand their rights and to show their numbers. Homosexuals only had

to look back at the sixties and the recent past of the decade that was ending to realize that the battle for gay rights was a fight best fought by gays and lesbians themselves. It helped to have straight friends who were powerful and influential, but save for a few exceptions, homosexuals found that allegiances lasted only until elections were over. Granted gays and lesbians had been finding more sympathizers and supporters in the 1970s than they had in previous years but, as events in the 1980s were about to prove, more often than not the homosexual community was left to care for its own.

GAYS HAD HAD ENOUGH. For most of the 1980s they watched helplessly as friends, partners, lovers and family members suffered and died from a disease that, from their perspective, had been allowed to snake murderously through the decade with little done to prevent its next strike. In 1987 the AIDS Coalition To Unleash Power was formed out of a need to "turn anger, fear and grief into action." ACT UP's members stormed events, staged sit-ins and loudly protested the complacency that had turned AIDS from a crisis into an epidemic.

In black T-shirts branded with slogans like "Silence = Death" ACT UP presented a type of guerilla

THE END OF the sixties and seventies had bookend riots in New York City's Stonewall Inn uprising and San Francisco's White Night Riot demonstrations. In both instances the beleaguered movement refused to back down when challenged.

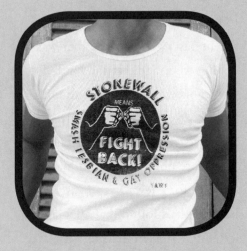

The T-shirts that were printed in reaction to the events of the last ten years were now pieces of history, and the fortitude with which they were created would serve as inspiration for the fight that was about to come. ●

activism that invoked the spirit of Stonewall but that was more sustained, and militant, than anything the public had witnessed from the gay community before.

ACT UP's attitude was justified, and also fittingly inciting, considering the cultural climate of the decade. When the masses weren't being anesthetized by

images of escapist excess, via TV shows like *Lifestyles of the Rich and Famous* and *Dynasty*, they were shown exercises in machismo one-upmanship in films like *Top Gun* and *Wall Street*. There were few signs of sensitivity or compassion in an era that could be defined by the famous "Greed is good" speech given by Michael Douglas's character Gordon Gekko in the latter film. Getting a message through all the talk about "power ties" and "acquisitions" required a strong delivery. And the gay and lesbian community fought vociferously to be heard.

Visibility remained an issue into the 1980s and GLBT individuals continued to come out in greater numbers. But for a rights movement that was feeling "we've come so far," a new mindset of "maybe we haven't gone far enough" was beginning to settle in. AIDS unfortunately added to the social stigma that had kept many gays in the closet.

"

My friend Buck in Indiana—who used to wear a homemade T-shirt with a pink triangle that said "Fag"—influenced me to start making my own T-shirts in college. I remember one with a big scarlet A and bloody handprints all over the chest. That went over great in Bloomington, Indiana, circa 1987. It was so much better than those "Nobody Knows I'm Gay" shirts. Heck, how could they **not** know?

KURT B. REIGHLEY

author, *Looking for the Perfect Beat*, and music critic

"

Fight Back

THE GAY RIGHTS MOVEMENT was facing old foes, and old attitudes, in the early years of the new decade. Slurs aside, the right to engage in homosexual activity, even privately, was routinely denied gays and lesbians. In the summer of 1982 a man in Georgia by the name of Michael Hardwick was arrested on sodomy charges for engaging in consensual, oral sex with another adult male in the privacy of his own home. Police had entered Hardwick's residence on the questionable charge that he failed to appear in court. The consensual nature of the act was not enough to protect Hardwick. Even if he'd been in an

ON AUGUST 12, 1980, the American tabloid *National Enquirer* ran a headline that was relatively tame by their standards, but still sensational enough to pique interest. Being August, it was the slowest month of the year for periodicals so a little extra titillation, even if it was only verbal, might help move a few more issues. "50,000 Weirdos March in Revolting Parade of Perverts!" the subtitle read. The headline expressed head-shaking disgust: "Sick!"

established relationship with the other man he still would not have been protected by the law in 1982: In the most progressive and gay-friendly city in the country, San Francisco's mayor killed a proposed bill in December of that same year that would have granted couples in same-sex relationships legal rights similar to those afforded

Sure, homosexuals were used to this kind of name-calling by now. They had endured years of derision for engaging in activity that was considered depraved if not psychologically deranged. The public sparring on the national stage with Anita Bryant a few years earlier had thickened some skins. T-shirts were now another piece of body armor.

Gays and lesbians were learning how to take abuse and rob it of its power to harm. In this case, the Enquirer's tear sheet was screened onto T-shirts; two strokes of a brush made a gigantic "X" through the "Sick!" headline.

But in an eerie, almost prophetic turn, the "Sick" T-shirt would take on a new meaning as AIDS began to ravage the world. Sufferers of the disease would use the very insults and slurs hurled at them to fight back at ignorance, disarming the attackers by using their own words in retaliation. ●

heterosexual married couples.

Gay rights advocates were accustomed to battles like these when the 1980s began. Frustrating as they were, at the very least they were familiar. The arguments used by the proverbial Other Side to keep gays and lesbians in the position of second-class citizens at best, degenerates hell-bent on corrupting society—especially

minors—at worst, were ones which the gay community had been learning how to address. Distasteful name calling, as featured on the *National Enquirer* cover, or ambushes like the faux sympathy Anita Bryant expressed over the precarious final resting place for unrepentant homosexual souls, were now anticipated. But AIDS was something new and entirely different. Discussions of the disease were characterized by panic. Rationality was a long way off, to say nothing of compassion.

JUST AS STONEWALL BECAME

a rallying cry and turning point for the homosexual community in 1969 and the years that followed, so AIDS would define one generation of gay men just as it nearly decimated another. AIDS threatened to undo the progress the gay rights movement had made as ignorance about the illness caused yet another shift in public opinion. That the disease was originally thought to only attack gay men served as easy evidence for attacks leveled against homosexuals by some religious leaders. AIDS was their proof that homosexuality and homosexual acts were unnatural, contrary to the laws of nature or the will of God. And that was just from a spiritual perspective. The actual physical aspects of the disease caused hysteria in the gay population as well as in the straight world. Rumors

spread unchecked as to how the virus that caused the illness was transmitted. The belief that casual contact, such as holding or shaking the hand of someone who was carrying the disease, could infect a previously healthy person was not unusual in the 1980s. Misinformation and utter lack of education resulted in the loss of jobs, denial of housing and family abandonment among gay men. A community that had spent decades fighting for freedom from discrimination in the workplace now had to face a new enemy in its battle for equality. Health care benefits were cut or denied. Employers hesitated to hire openly gay men out of fear for their company's physical and fiscal health.

The Human Immunodeficiency Virus, or HIV, the virus eventually found to cause AIDS became the new stigma among an already marginalized minority even when symptoms were not apparent. Signs of effeminacy or weakness, once considered a sure tip-off to one's homosexuality, were now often equated with signs of illness in the gay and straight worlds alike. Just as during the war years some gays reported distancing themselves from soldiers who were less masculine fearing guilt by association, not surprisingly there were those within the gay community that turned their backs on their AIDS-stricken brothers.

Confronting AIDS as a community was as difficult an endeavor as finding an agreed-upon approach for the social and political issues homosexuals faced when the nascent rights movement first debated such tacks. As the medical community scratched their heads as to the cause of the symptoms they were seeing among gay male patients and intravenous drug users, the gay community realized it had its worst public relations nightmare yet—not to mention another issue to divide the community. Because the human immunodeficiency virus (or HIV) had not yet been isolated, the exact means of transmission of an agent that would cause AIDS, from one person to the next, was a matter of speculation. It was anybody's guess.

What should leaders in the gay community say publicly about the new disease? Anything at all? There was talk of promiscuity being to blame, but raising that as a possibility as well as the very word itself sounded too similar to the kind of admonitions homosexuals had been hearing from religious conservatives for years. The issue of sexual freedom was at the core of gay liberation for many advocates of gay rights. The issue of whether refusal to be more public about aspects of same sex sexual relations was a divisive one within the gay community. The stodgy or prudish attitude that

favored side-stepping the issue of what gays do in their bedroom was seen by liberation advocates as being as restrictive as the sodomy laws. But as more gay men began showing up in doctors' offices with symptoms of the yet to be named AIDS, a very public discussion was initiated about very private matters.

An early theory about AIDS' origin proposed that since gay men frequently had numerous sexual partners—as admitted by patients who first sought treatment—an increased exposure to venereal diseases had simply taxed their immune systems. The immunologic overload theory suggested that frequent battle with diseases like hepatitis and mononucleosis, an ailment known as gay bowel syndrome, not to mention any number of illnesses such as gonorrhea, syphilis or herpes exhausted a person's immune system to the point where it finally shut down. The means of transmission of these conditions was soon part of the forum, as was the use of amyl nitrate and butyl nitrate among gay men to achieve a better orgasm. Now people who'd never known any homosexuals, or at least thought they hadn't, were becoming familiar with terms like "poppers" and "rimming" simply by reading the papers or watching talk shows like Phil Donahue's.

IN THE AIDS EPIDEMIC'S first few years, infighting among gays increased as leaders debated the best course of action for the community's health and well-being. Regarding those gays who favored the closing or censorship of the baths, it seemed like portions of the gay community were once again siding with forces that were making decisions for them. Internal rancor

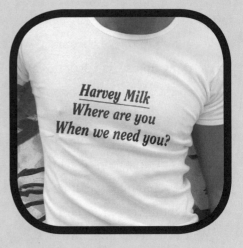

was more dangerous than ever since the government's response to the growing epidemic was one of mild interest at best. As death tolls rose, gays were quickly learning they were going to have to fight for their own like never before.

HOW WAS THE gay community to respond? Major players in the gay press were uncertain, taking a "wait and see" approach while gay political groups were similarly hesitant to sound any alarms. The Harvey Milk Gay Democratic Club in San Francisco called for immediate education of

Compassion and concern from government and church leaders alike were slow in coming. The gay community needed leadership and unity within its own ranks.

"Harvey Milk Where Are You When We Need You?" was a timeless question. Milk had been a strong opponent of putting the community's fate in the hands of anyone who acted according to what he saw as the straight establishment's bidding. He also knew that at times gays and lesbians listened to voices from their own camps that in his opinion were too moderate or even timid. Regarding gay rights Milk had famously said, "You're never given power. You have to take it!"

As the question of how to address AIDS edged community relations towards collapse it was hard not to wonder "WWHD?"—"What would Harvey do?"

"Harvey Milk Where Are You When We Need You?" would become an unfortunately familiar refrain for many, not only during the 1980s but also in the decades to come. ∎

the community about the disease. Its members believed they were acting in the spirit of their namesake whose lifework was devoted to the creation and preservation of a safe environment for homosexuals. T-shirts asking, "Harvey Milk Where Are You When We Need You?" were

worn by activists who had grown weary of the infighting the AIDS issue caused in the community.

Time was not on anyone's side. People were becoming infected, and dying, as the debate raged as how to best spin the illness to the community, the media and the rest of the world.

THE GAY MEN'S HEALTH CRISIS,

formed in early 1982 in New York City by a group that included outspoken gay writer Larry Kramer, began mailing a newsletter in July of that same year to a growing list of men desperate for any information about the mysterious illnesses that were befalling more and more of their friends. What was confounding medical professionals and activists alike was the disease's elusiveness. Strange forms of cancer like Kaposi's sarcoma were being seen alongside a deadly pneumonia. In others, debilitating fatigue and unexplained weight loss were present. The gay community had to be warned about this threat. But telling the public how to defend itself against the disease was particularly difficult since even the medical community had to admit it was fighting an enemy that it could not see and that it couldn't even identify.

In July of 1982 members of the gay community, along with medical professionals who'd been hunting the cause of symptoms and monitoring

their progression in patients, met in Washington, D.C. with government officials. The evidence they reviewed showed that an epidemic—of a disease for which there was no known cause—was under way; and not only was it spreading rapidly, it was now casting a wider net for its victims. Originally known as GRID, or gay-related immune deficiency, the illness was renamed AIDS on July 27, 1982. Acquired immunodeficiency syndrome was a better name for the ailment since gays were no longer the only group showing signs of infection. In addition to the IV drug users, heterosexual prostitutes and recipients of blood transfusions also were showing signs of infection.

The Centers for Disease Control and members of the medical community in cities like New York, San Francisco and Los Angeles tried to isolate the agent responsible for spreading the disease. The exchange of bodily fluids with another person, either sexually or through shared IV needles, was one similarity all patients had in common. Another parallel among gay male patients was that many of them frequented the gay bathhouses and engaged in sex on the premises, sometimes with multiple partners.

ON MONDAY, APRIL 9, 1984,

over three years into the AIDS epidemic, Dr. Mervyn

Silverman and the San Francisco Department of Public Health demanded the city's bathhouses enact a ban on on-site sex.

Silverman's proposal was the ultimate affront to the gay libbers. After decades of having their behavior policed by law enforcement officials who harassed gays and lesbians simply for socializing in public spaces, this ban was an invasion of privacy on a par with a civil liberties violation. That support for this censoring of activity was coming from a faction within the gay community itself was thought to be nearly treasonous by some gay men who fought to keep the baths open and behavior

inside unrestricted. What better environment than a gay bathhouse to educate homosexual men about the risks involved with certain types of sexual acts, they argued. Considering that a portion of the gay population was not comfortable discussing their orientation, let alone their sex lives with their doctors, this made an interesting case for the pro-bathhouse side of the debate. At the baths they could receive literature and information about AIDS. They could learn about the sexual practices that were considered high risk. But for those who favored closing the baths, the fact that the bathhouses were the scenes of some of those

high-risk behaviors was reason enough to close the doors.

The debate became more contentious in San Francisco when it was learned that then-Mayor Feinstein had sent undercover, or rather towel-wrapped, police personnel to the city's baths to monitor the goings-on inside. Those gays who favored the closing or censorship of the baths were viewed as siding with forces from outside the community that were making decisions for gays. Such infighting among homosexuals was more dangerous than ever since the government's response to the growing epidemic was one of mild interest at best. Gays were quickly learning that they were going to have to fight for their own like never before. Compassion and concern from government and church leaders alike were slow in coming.

GOVERNMENT FUNDING for research was pitifully low, addled by a decrease in monies allocated for the Centers for Disease Control under the Reagan Administration. Other programs like those at the National Cancer Institute that could have helped with research and testing programs were stalled due to allegedly flawed grant proposals; a lack of "focus" was routinely cited as the roadblock. "How can you "focus" a grant

ON MONDAY, APRIL 9, 1984, over three years into the AIDS epidemic, the most controversial announcement since the disease claimed its first victims appeared in newspapers: Because engaging in sex with numerous partners increased the likelihood of spreading AIDS, the San Francisco Department of Public Health demanded the city's bathhouses enact

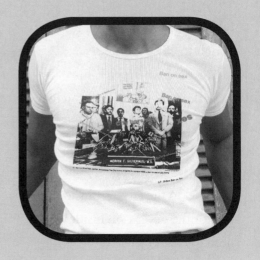

application concerning a disease that has been known to exist for only [then] twenty months," Randy Shilts reasoned in *And The Band Played On,* his epic that chronicled the advent of the AIDS tragedy.

When the United States

government finally did start to discuss the AIDS nightmare some of the solutions it allegedly proposed to contain the spread of the disease included the reinstatement of practices that were terrifyingly reminiscent of those of Nazi

a ban on sex on their premises. "City bars sex!" and "Ban on Sex!" were inked across T-shirts silkscreened with the photos taken at Silverman's press conference that had appeared in the *San Francisco Examiner* that day.

The issue and the decision were divisive in the community. Charges that civil liberties were being violated stoked one faction, while cries of reckless endangerment incensed another. For some gay men the ability to freely engage in sexual activity was the singular issue at the core of the gay rights movement, since the orientation towards same sex sexual attraction was what identified them as homosexual in the first place. Restricting sex, and closing the bathhouses, would be a step backward.

Germany. Mandatory AIDS testing of the entire American population was suggested as one way to assure that those who had the virus did not contaminate others. It was rumored that infected persons would be tattooed.

AIDS AWARENESS in the country continued to be a mix of bigotry, misinformation and complete ignorance by the mid-eighties. Posters urging sexually active adults to wear condoms as a means of reducing the risk of infection

Also featured on the "Ban on Sex!" T-shirt, sitting above the press photo, was an editorial-style cartoon of a police officer looking through what could be construed as a "glory hole." "City's gay baths stay open," read its caption. Since the police had long harassed homosexuals in San Francisco and elsewhere, the cartoon cop's portrayal was open for interpretation. Was he a voyeur, secretly longing to join in the action? In a controversial order, police had been dispatched into the baths at the order of Mayor Feinstein to curb any sexual activity. Was this officer one of Feinstein's henchmen, or was he making sure the coast was clear for his own purposes? ■

were considered too controversial. Offended conservatives argued that such language and instruction only condoned promiscuity and immorality. Despite the growing AIDS crisis, decorum took precedence over disease prevention. And saving lives.

Despite the fact that other members of the population were becoming infected, AIDS remained synonymous with homosexual men in the majority of the public's mind. Hateful riffs on the acronym made the rounds: "AIDS: stands for Aloha Ignorant Dick Suckers," or "GAY: stands for Got AIDS Yet?"

SUCH VITRIOL was not uncommon. With the majority of public sentiment landing somewhere between indifferent and hostile, gays again had to turn to their own ranks for support. Early benefits featured participation from openly gay artists, like David Hockney in the San Francisco Artists Against AIDS event. Gay-friendly performers such as Debbie Reynolds hosted fund-raisers. Few people were brave enough to have even their names come in close contact with the disease. And even fewer still were willing to disclose their health status though it was clear they were suffering from AIDS-related illnesses. When famous people from the world of fashion and entertainment turned symptomatic, questions about their health were met with silence.

IN 1986 AN UNLIKELY ALLY for the gay community and the fight against AIDS came from within the very administration that for so long had done nothing to educate the public on the fear/fact/fiction aspects of the disease. Reagan's choice for Surgeon General, C. Everett Koop, released a report on the disease with a methodical approach on fighting the spread of the illness. The anchor for his plan was education: Educate the public on the cause of the disease, the transmission of the disease, and most

WHEN THE United States government finally did start to discuss the AIDS nightmare some of the solutions it proposed to contain the spread of the disease included the reinstatement of practices that were terrifyingly reminiscent of those of Nazi Germany. Mandatory AIDS testing of the entire American population was suggested. It was rumored that infected persons

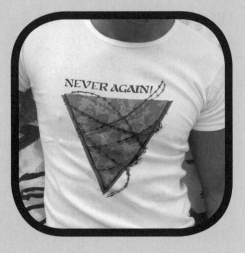

would be tattooed: What couldn't be seen lurking in the blood would at least

importantly, educate the public on the prevention of the disease. Rather than the ideology that gay activists feared would be threaded through Dr. Koop's findings, the report relied on medical fact and sounded a pragmatic tone in its call for sex education in classrooms. Its most shocking content was its uncompromising stance on the issue of condoms: The report declared condoms essential to stopping the virus from spreading.

be forewarned by permanent ink on the skin. Other, darker means of halting the spread of the disease considered isolating persons with AIDS in specially designed "hospital-bed facilities" or treatment centers. Comparisons between such hospitals, as suggested by presidential candidate Lyndon LaRouche, and leper colonies or concentration camps were inevitable.

Pink triangles began to appear more frequently on clothing, stickers and flags as a symbol of the persecution gays were experiencing in the AIDS era: a fitting emblem since the Nazis had forced homosexuals to wear pink triangles, just as Jews had been forced to wear yellow Stars of David. T-shirts carried images of the now-iconic pink triangle, wrapped in barbed wire, with the words "Never Again!" defiantly written across the front. ■

While Koop's plan was solid, the feeling that it could have come sooner was a common one held in the gay community. Although someone from the establishment was finally taking notice of the plight of those not yet infected, those already suffering from AIDS were left to wonder if the promise for proper funding would be kept; gays and lesbians had been placated before over less controversial issues by politicians seeking their vote

THE ARC/AIDS VIGIL shirt from 1985 reflects a country still fighting an unknown enemy. ARC, or AIDS-related complex, was the term used to identify several infections and conditions among AIDS patients prior to the isolation and naming of the HIV virus.

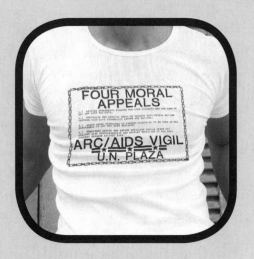

As stated by the call for the "Four Moral Appeals" on the back of the shirt, AIDS awareness in the country continued to be a mix of bigotry, misinformation and complete ignorance at the time the Vigil was held in the mid-eighties. Public posters urging all sexually active adults to wear condoms as a means of reducing the risk of infection were considered too controversial. Offended conservatives argued that such language and instruction only condoned promiscuity and immorality. Despite the growing AIDS crisis, a select group's notion of decorum took precedence over disease prevention. And over saving lives.

While the appeals asked for health care and drugs for those suffering from AIDS, the organizers of the Vigil also had to overcome a national attitude that was

88

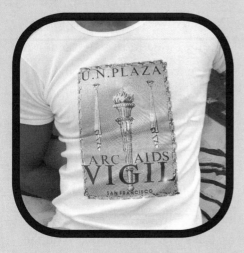

prudish and squeamish if not openly hostile: Asking for compassion should not have been such a radical request. But in a country where leaders are often looked upon as role models, the American public was merely following the example set by its president in regards to AIDS. Then-President Ronald Reagan made it through nearly six years of his eight years in office before even once publicly saying the word "AIDS." Nearly thirty thousand human lives were lost before the Reagan Administration took action. Pleas for the "Four Moral Appeals," as outlined by the ARC/AIDS Vigil staged at the U.N. Plaza—and on the back of the T-shirt—called upon "President Reagan and Senior Officials [to] speak out against AIDS discrimination and support education as our only current defense against AIDS."

With such negligence on the part of officials in power, a new kind of activism and a new breed of activist were needed to combat the ignorance and indifference that were spreading, like the AIDS virus, unchecked. ●

only to have that commitment broken after the candidate was elected.

With education at the center of Dr. C. Everett Koop's AIDS report, there was hope that increased awareness in the general public would abolish ignorance about the disease. Ignorance had allowed the virus to spread, unchecked, as people continued engaging in behaviors that were putting them at risk. Those who lived in urban environments had a slight advantage in receiving early warnings about AIDS and its means of transmission, when compared to their suburban or rural counterparts, only because of proximity to the disease's epicenters. But social condemnation and the fear of being discovered were responsible for creating a long history of clandestine sexual encounters, both in and out of metropolitan areas. Prior to Koop's report, information about AIDS prevention was less accessible. Even on major college campuses as late as 1985 information about safe sex, or safer sex practices, was not readily available. Gay men familiar with the efficacy of condom use educated their uninformed sex partners about the importance of protection.

The advent of condom use, and the importance of using lubricants with agents like Nonoxynol 9, became another source of conflict in the gay world. Some men saw condoms as yet another imposition

by straight society upon their right to live and love as they chose. Condoms, in their opinion, were for the purpose of preventing pregnancy, not the halting of a disease. Other men found putting on the brakes to put on a condom was an immediate, and ultimate, buzz kill. Nothing ruined the mood like being reminded that the activity you were about to engage in could eventually infect you with a disease. The "live for the moment" attitude of these gay men infuriated certain gay leaders who couldn't believe this type of activity could grow into a trend. Meanwhile the barebackers—men who had renounced condom use—believed

no one could tell them what to do with their bodies so long as both parties were consensual.

Again, education remained the best weapon against ignorance. Condom demonstration "home parties" were the AIDS-era take on Tupperware Parties from previous decades. Organizations founded to serve as outreach posts for the growing number of AIDS cases in cities, like HERO in Baltimore, MD., established volunteer networks for the dissemination of information about AIDS prevention and safe sex practices. Armed with packs of condoms and grocery bags full of bananas, volunteers would give the assembled a demonstration on the

AS THE AIDS EPIDEMIC spread, victims of the illness were marginalized, as some gays distanced themselves from those who had the disease.

The use of the line from Whitman's poem, "As Adam Early in the Morning," from his *Leaves of Grass* collection, begs for compassion not only from the country as a whole, but, since Whitman himself wrote that "poetry is the result of the national spirit," from homosexuals in particular.

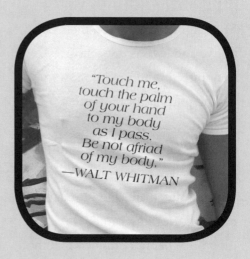

"Touch me, touch the palm of your hand to my body as I pass. Be not afriad of my body." —WALT WHITMAN

proper way to use a prophylactic. Pamphlets containing literature about AIDS prevention as well as information about testing were distributed along with free condoms to guests at these parties.

The home parties and the condom demonstrations were a way to humanize the AIDS crisis, banana excluded, in a safe, nonthreatening environment. Activists knew that familiarity was one of the ways to

Whitman had assumed the role of male nurse during the Civil War and found himself at the bedsides, and deathbeds, of the fallen, men with injuries and disfigurements that could be unsettling to witness. In this context "Be not afraid of my body" reminds the reader that the spirit of the person remains despite the disease's ravaging of the body. The reference on the front of the T-shirt to finding solace in the "Dear Love of Comrades" echoes Whitman's experiences on several levels. It addresses his discovery of homosexual kindred spirits during the years he lived in New York, just as it ties together his sympathetic displays to the wounded on the battlefield. Both experiences from Whitman's life are seen as correlating to the gay community as it struggled to come together to fight the war against prejudice and AIDS in the 1980s. ∎

break down people's defenses and educate them about the disease. Visibility was another. But asking or expecting people suffering from AIDS to come out and go public with their illness in the mid-1980s was akin to asking people to come out during the conservative and homophobic periods of the 1950s and 1960s when gays and lesbians risked everything by admitting their orientation. One early self-appointed

THE BLUNT STATEMENT made by the Clark Wants Dick—Dick Wants Condoms T-shirt at the close of the 1980s was tame in comparison to the revolutionary imagery of other AIDS-era messages, like those from Act Up. But the T-shirt, which depicted ubermen Dick Tracy and Superman/Clark Kent in a lip-lock, deployed the gay movement's latest weapon in its

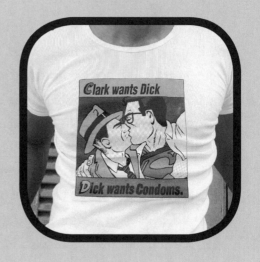

and self-proclaimed poster boy was San Francisco's Bobbi Campbell. Campbell died in 1984 due to complications from AIDS. By putting a face on the disease Campbell became more than just another statistic.

In the community, friends and family who lost loved ones to AIDS felt the dead needed to be honored and remembered, and that the rest of the world had to know how much was lost when these individuals died. San Francisco resident Cleve Jones began creating a memorial. With the

battle against AIDS. Using pop art imagery that was currently in vogue, the T-shirt broke a social taboo beyond its portrayal of two All American males as homosexuals: It blatantly advocated condom use.

What was even more shocking was that condom usage, as a means of AIDS prevention, was endorsed by the United States Surgeon General C. Everett Koop. Shortly after his appointment to the post in 1986 by President Reagan, Dr. Koop released a report containing a methodical approach on fighting the spread of AIDS that included an uncompromising stance on the issue of condoms: They were essential to stopping the virus from spreading.

The status of condoms changed from being something teenage boys boasted

Names Project Memorial Quilt begun in 1986, Jones found a way to pay a lasting tribute to his friend Mark Feldman by stitching a quilt square that commemorated Feldman's life. Jones encouraged others to do the same for their friends and loved ones; the relationships that had brought comfort were now immortalized in the form of something that was a traditional symbol of warmth, comfort, safety and home. And like a traditional quilt, Jones' original panel could be added to, a somber

about carrying in their wallets into a life-saving and non-negotiable part of sexual relations in the 1980s. By the time Michael Stipe of the band R.E.M. appeared at an MTV Awards show wearing a T-shirt endorsing condom use, condom demonstration "home parties" were the AIDS-era's version of Tupperware parties from decades earlier. Armed with packs of condoms and grocery bags full of bananas, volunteers would give the assembled a demonstration on the proper way to use a prophylactic. Pamphlets containing literature about AIDS prevention as well as information about testing were distributed along with free condoms to guests at these parties. T-shirts commemorating condom stretching contests or endorsing "latex lovers" had become common by the decade's end. ∎

and foreboding reminder that AIDS would continue to kill.

A MARCH ON WASHINGTON for gay and lesbian rights was organized for October of 1987, and a display of the quilt's panels was planned as part of the weekend's events. Building upon the importance of visibility, gay and lesbian leaders called for all homosexuals, bisexuals and transgender people to speak up and speak out about their lives. Only in destroying the closet

could the community be free, they urged. As long as orientations were hidden from families, employers and neighbors, those living in the closet were empowering others. Being open, and out, reclaimed and saved lives. National Coming Out Day was planned for October 11, 1988, the anniversary of the previous year's march on Washington, D.C. With a poster featuring artwork by gay and HIV+ artist Keith Haring, the event attracted the interest of numerous media outlets. The message of National Coming Out Day, to paraphrase its motto, was the next step not only for the GLBT community as a whole but also for those community leaders and activists who'd been trying to define the role and character of the community in the AIDS era.

THE IDEA THAT one's coming out should occur on a date chosen by others wasn't seen as being very liberating to some gays and lesbians. Having someone else decide, whether those individuals were gay leaders or not, when a person should share such a private part of their lives as their sexual orientation was found to be somewhat dictatorial. This type of disagreement was reminiscent of the discourse that caused the first gay rights groups to split into separate organizations in the 1960s. But the AIDS crisis called for bold action. In the 1980s coming out

CLEARLY, THOSE who were wearing T-shirts announcing their own orientation, or supporting the homosexual orientation of others, were already out. But this type of visibility was what gay leaders hoped could become the rule, rather than the exception that it had been in the past. Calling for all homosexuals, bisexuals and transgender people to speak up and speak out

was seen as the least one could do. For some gays and lesbians it was an obligation, if not a necessity.

A feeling that the gay community needed to be mobilized into action, like an army to defend its own, characterized the second half of the 1980s. As Lynn Shepodd from the Human Rights Campaign said, "You cannot have an invisible movement." The GLBT community needed to be seen and heard more than ever, and one gay organization was determined its message would be heard—by the

about their lives was always essential to the push for GLBT equality, in the minds of the community's leaders. Only in destroying the closet could the community be free. As long as orientations were hidden from families, employers and neighbors, those living in the closet were empowering others. Being open, and out, reclaimed and saved lives. National Coming Out Day was planned for October 11, 1988. The message of the National Coming Out Day T-shirt, "Take The Next Step," was intended as a call to action for the splintered parts of the GLBT community who were in disagreement over how the community as a whole should position itself and its struggle for equal rights in the AIDS era. Posters featuring the artwork of Keith Haring helped publicize the event. ∎

government, the medical community, the pharmaceutical industry and the world—loud and clear.

"THERE NEVER WAS a politically savvy group of sick people before," a somewhat astonished George Annas told the *New York Times* in March of 1990. Annas, the director of the Law, Medicine and Ethics Program at the Boston University School of Public Health, was referring to the organization that called itself Act Up. As an activist group, Act Up had

THE AIDS COALITION To Unleash Power—or Act Up—was formed in 1987 by gay activists Larry Kramer, a founding member of the early AIDS group The Gay Men's Health Crisis, and Martin Robinson, a cofounder of the sixties' group the Gay Liberation Front, along with other New York AIDS policy advocates.

Its logo, either printed on T-shirts or spray-painted on walls, became a symbol of an anarchist-like, by-any-means-necessary mindset. Admitting allegiance to Act Up publicly, by participating in their demonstrations or wearing an ACT UP T-shirt, was aligning oneself with the most extreme forms of activism the gay movement had ever spawned. Whether staging a sit-in on San Francisco's Golden Gate Bridge or interrupting the celebration of Catholic Mass at St. Patrick's Cathedral in New York City, Act Up's methods were the types of actions that got attention. ●

achieved the kind of results that revolutions are made of. Depending on whose opinions were sought, the coalition's members were considered outlaws, scourges, militants or heroes.

The AIDS Coalition To Unleash Power—or Act Up—was formed in 1987 by gay activists Larry Kramer, a founding member of the early AIDS group The Gay Men's Health Crisis, and Martin Robinson, a co-founder of the sixties' group the Gay Liberation Front, along with other New York AIDS policy advocates.

Radical from its inception Act Up was, some would say, the inevitable response from a frustrated community who refused to allow more people to die while insensitive bureaucrats and profit-minded pharmaceutical companies hammered out the finer points of public policies, research funding and drug trials. Being patient was not an option as the disease spread and death tolls mounted. After nearly six years of studying AIDS, why was there still only one drug on the market? Why was that one drug, AZT, so expensive? And why wasn't the government doing more? In the last half of 1987, President Reagan's panel of thirteen medical and health care experts, the Presidential Commission on the HIV Epidemic, met for the first time to plot the administration's course of action for dealing with the epidemic. Its findings would then be released

in June of 1988. In a little more than six months a new administration would be in office, an administration that would have its own AIDS agenda. AIDS activists found little reason for hope with this commission. One of its members warned that AIDS infections could occur from a toilet seat while another called gay men "blood terrorists," charging that they intentionally sabotaged the nation's blood banks by donating HIV contaminated blood. Add to these mindsets that the president who assembled them all together had wondered "…when it comes to preventing AIDS, don't medicine and morality teach the same lesson," and there wasn't much about which to feel optimistic. California Democrat and House Representative Henry A. Waxman voiced the concerns of many when he pointed out that the commission consisted of individuals who were chosen for the panel "because they knew nothing about AIDS or had already made up their minds to go along with a right-wing agenda rather than a public health agenda in dealing with the disease."

The president's comments on "medicine and morality" and condemnation by conservatives of the panel's lone openly gay physician—Dr. Frank Lily—as a "special interest group" representative were the type of biased comments and opinions that infuriated AIDS activists, and led

them to believe that only by taking matters into their own hands could they get results. Since AIDS was a new type of epidemic, battling it required a new kind of activist. Marches were fine for being seen, and they might even garner the assembled group a modicum of respect, but staging a sit-in on San Francisco's Golden Gate Bridge or interrupting the celebration of Catholic Mass at St. Patrick's Cathedral in New York City were the types of actions that got attention. And once the members of Act Up had that attention they knew how to use it to the best advantage of their cause. As Larry Kramer told an assemblage at a Food and Drug Administration meeting in Washington, D.C. in

August of 1988, "I helped found Gay Men's Health Crisis and watched them turn into a sad organization of sissies. I founded Act Up and have watched them change the world."

Kramer's distinction between his two progeny was dramatic, but his assertion that Act Up had enacted real change was hard to dispute. When drug manufacturer Burroughs Wellcome ignored requests from activists to lower the cost of AZT, the prescription drug it manufactured for use in treating AIDS and HIV+ patients, Act Up staged a demonstration at the New York Stock Exchange to protest the company's stance. They also performed guerilla-style "actions" in drugstores and

THE NINETIES BEGAN where the 80s ended, with AIDS drug development and government clearance still painfully slow. This shirt, from the Golden Gate chapter of Act Up in San Francisco, called for immediate approval for the use of drugs DDI and DDC in the treatment of AIDS patients. The headline "10 Years—1 Billion Dollars—1 Drug" and "Enjoy AZT" referenced

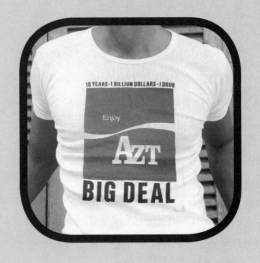

supermarkets, labeling Burroughs Wellcome's over-the-counter items with stickers reading "AIDS Profiteer."

Two weeks after refusing to lower its price, Burroughs Wellcome announced a 20 percent reduction in the cost to the consumer of AZT, and in a very public victory for Kramer and Act Up a representative for the pharmaceutical giant cited Act Up's protests as one of the reasons for reversing their decision.

There was still much resentment surrounding AZT and AIDS drugs in

the way drug companies had been able to capitalize on the illness using the simple supply and demand business model. As long as Burroughs Wellcome, the manufacturers of AZT, allowed only one drug on the market they maintained a monopoly. Even if they developed other medicines, but withheld their release, they could remain their own best competition—and charge whatever price they wanted. The shirt's appropriation of Coca-Cola's red wave logo, "Enjoy AZT" and "Big Deal" mimicked the soft drink's "Have a Coke and a smile," and "Coke, it's the Real Thing" slogans with a sarcastically dismissive tone. By comparing AZT to Coke, Act Up was pointing out the corporate mentality that was making AIDS treatment more about marketing than medicine. ∎

general within the gay community and among AIDS activists. The FDA had been achingly slow to approve various medicines for use in America, claiming long-term side effects were potentially risky. AIDS activists found that reasoning laughable as well as infuriating. In the mid-eighties the use of the phrase "long-term" in reference to drug therapies planned for someone diagnosed with AIDS was ridiculous: Life spans after diagnosis were typically no more than a few years, if that. By the end

ONE OF THE MOST visually arresting images Act Up created was that of the upside down pink triangle resting on top of the words "Silence = Death." The message was twofold. "Silence = Death" not only charged the government that its years of inaction and the President's refusal to publicly address the AIDS crisis had contributed to the deaths and infections of countless people, the

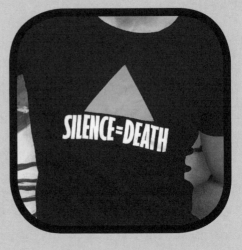

slogan also issued a grim warning to homosexuals who chose to remain in the closet: Allowing others to speak on your behalf, or not making your voice heard, Act Up admonished, was a matter that had life or death consequences. ◼

of the decade AZT remained the only pharmaceutical to have been approved by the FDA, yet the drug's side effects were as debilitating as the symptoms of the disease it was originally designed to treat.

Calling attention to the drug company's profit mindedness in

the manufacturing and sale of AZT, Act Up produced one of their most clever visual "actions" with their "Enjoy AZT" T-shirt. The organization appropriated the image of the corporate giant Coca-Cola and their well-funded advertising machine, by employing the red and white Coke logo, including the soft drink's trademarked "wave." "Enjoy AZT" was Act Up's way of calling attention to the government and the FDA's "don't worry, be happy," attitude. "Have a Coke and a smile," and while you're at it "Enjoy AZT."

ACT UP'S IN-YOUR-FACE activism was something the gay rights movement had never experienced

before. Part theater, part anarchist ideology, and part human rights campaign, the AIDS advocacy group took a punk rock do-it-yourself approach to getting its message heard and having its agenda met. "Act up! Fight back! Fight AIDS!" was one of the group's rallying cries. Another, "Silence = Death" was used in what would become one of Act Up's most iconic images: The slogan appeared underneath or alongside an upside down pink triangle. The phrase "Silence = Death" not only charged the government that its years of inaction and the president's refusal to publicly address the AIDS crisis had contributed to the deaths and infections of countless

ARTIST KEITH HARING, who died of AIDS in 1990, created this and other images in his effort to use his art—and art celebrity status—to educate the public about the disease. In a T-shirt appropriating Act Up's mottos, Haring displayed the classic figures—"See no evil, hear no evil, speak no evil"—that embodied the ignorance and fear that had characterized avoidance of the topic

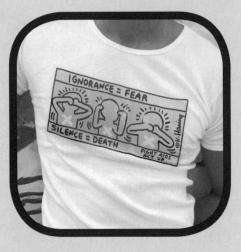

of AIDS. Haring's artwork advocating safe sexual practices would appear on his canvases, occasionally gracing other T-shirts. Other images of his promoted awareness and acceptance of gays and lesbians. His stylized figures had already become iconic images of the 1980s by the time he went public with his illness. ●

people, but the slogan also issued a grim warning to homosexuals who chose to remain in the closet.

ACT UP ALIENATED some gays who agreed with the group's intentions but felt that their tactics

were bullying and would sooner or later backfire. By early 1989 Act Up had intimidated enough members in the medical and research fields that some doctors and scientists feared for the future of the AIDS field. No one would want to risk raising the ire of Act Up, nor would they want the activists constantly peering over their shoulders.

Regardless of whether others agreed with Act Up's methods, what could not be disputed was that when they spoke, the powers-that-be listened. Mr. Kramer's assertion that Act Up changed the world may have sounded like bravado to some but there is no denying that the Food and Drug Administration's

decision to release drugs still in the experimental phase of development to AIDS patients who needed them can be credited in part to Act Up's refusal to remain silent, and their determination to fight back.

ACT UP AND National Coming Out Day were two examples of the gay rights movement's emphasis on the importance of visibility during the AIDS-plagued 1980s. Falling somewhere in between the no-holds-barred activism of Act Up and the more PR-friendly approach of the NCOD organizers were PiSD, or People With Immune System Disorders.

"INVISIBLE" WOULD HAVE BEEN

the antithesis of the philosophy behind the Act Up offshoot, Queer Nation. Sporting T-shirts with a gigantic letter Q, with the words "We're here! We're queer! Get used to it!" Queer Nation's slogan was one of the blatant and unwavering messages that demanded society's acceptance of the GLBT community at the end of the 1980s. Wearing T-shirts that simply read,

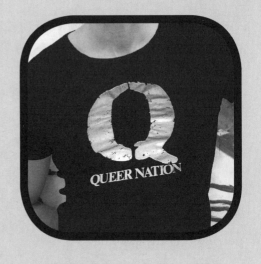

"Queer Nation: Get Used to It," the gay rights movement was saying to the world "We're not going away."

Part of the force of Queer Nation's T-shirt message came from the use of the word "queer." In reclaiming the word that had been used as a slur, members of the group followed the tradition that "names" could never hurt them. At a time when gay-bashing incidents were on the rise, the public declarations espoused by Queer Nation's shirts were as much about defiance as they were determination. ∎

THE BITTER ANGER and resentment felt by many towards Ronald Reagan and George Bush in the gay community during the 1980s and beyond cannot be understated. Their refusal to acknowledge publicly that a public health crisis was unfolding bordered on criminal negligence in the minds of some AIDS activists. People were suffering, people were dying, yet nothing was being done. Funds for research and treatment were slow to reach allocation.

Reagan's rocky history with the gay rights movement started during his governorship of California when he threatened to veto any bill that proposed the decriminalization of gay sex, though he later spoke out against the Briggs Initiative and Proposition 6, which would have made it lawful to discriminate in cases of employment based on sexual orientation. It was a brief display of awareness that homosexuals were deserving of equal human rights.

The AIDS emergency was a test for any national leader. In a nation where a good portion of society was not accustomed to speaking about its gay population in anything other than condemning or pejorative terms, addressing a disease which was contracted through intimate male-to-male sexual contact required a level of sophistication, tolerance, acceptance

THE 1990S SAW a continued increase in the media of gay and lesbian and even bisexual characters, and not all of the representations were considered favorable. When the movie *Basic Instinct* was released in 1992, gay groups protested the film because of the main character's homicidal tendencies, arguing that the movie would continue to perpetuate the image of

gays, lesbians and bisexuals as emotionally disturbed—a throwback to the days when homosexuality was still considered a clinical psychological disorder. In a declaration as over the top as the movie itself, the back of the Catharine Did It Tee (complete with her character's murder weapon of choice as the letter "I" in her name) warns viewers "Do not agitate" the wearer as they are an "Ice pick–wielding bisexual fag-dyke." ●

and compassion which President Reagan never displayed. He and his wife Nancy Reagan were well acquainted with numerous gays and lesbians and several Reagan staffers were known to be homosexual. Regardless of their private friendships when it came to their public life the actor-turned-politician and his actress-now-First-Lady opted to present a unified front to the nation, particularly their conservative voting base. Nancy did her part by giving interviews in which she accused gays of being the cause of the "weakening of moral standards" in America. She opined in *The Boston Globe*, "What in the world do [participants at Gay Pride celebrations] have to be proud of?" Her husband did his part by ignoring the suffering of thousands of human beings. (In an interview with television talk show host Larry King in 1990, when asked by King if his presidency had ignored the AIDS epidemic, Reagan would say that his administration had had "catching up" to do in addressing the crisis.)

THE REFUSAL OF the Reagan administration to publicly address the growing AIDS crisis brought up questions of conspiracy. Could the HIV virus possibly be a man-made, laboratory invention created specifically to wipe out the minorities the establishment found

FALLING SOMEWHERE BETWEEN

the no-holds-barred activism of Act Up's strident "Silence = Death" message and the humorous approach of the Lesbian Avengers was the *Diseased Pariah News*. Promising to be "More Than Just An HIV Humor Magazine," the minds behind DPN (as its name was abbreviated) applied a sardonic interpretation to the adage that laughter

abhorrent? It sounded like paranoia, but the idea that thousands of people would be allowed to become ill, and die, without intervention was mind-boggling. What kind of individual allows that to happen? Wasn't this a form of genocide?

IN 1987 Surgeon General C. Everett Koop foresaw the threat inherent in the spreading of a disease that seemed to be attacking minorities. "How tragic...for America," he said in an address to the President's AIDS commission, that, "this disease is

was the best medicine. One T-shirt displayed a cover of the magazine and featured a savagely funny reworking of the classic Palmolive dishwashing detergent commercial. As the manicurist gently tapped her customer's hand back into the red liquid it had been immersed in, a cartoon bubble caption read "The blood of over 100,000 Americans dead from AIDS, Mr. President? Why you're soaking in it!" The tone of the shirt's matter-of-fact tag line was a grim reference to the mounting toll AIDS was taking across America. By printing such a headline on a T-shirt, *Diseased Pariah News* not only held the Reagan and then Bush administrations' slow response to the epidemic accountable, it also increased the "pass-on" rate of distribution for its message. ∎

becoming the scourge of people who are young, black and Hispanic."

Gay-bashing increased in the second half of the eighties and the National Gay and Lesbian Task Force told *The New York Times* "hatred and blame associated with the [AIDS] epidemic continue unabated," in June of 1989. The attacks were not only continuing, they were escalating. In 1988 there were more acts of violence directed against homosexuals than in 1985, 1986, and 1987. Especially distressing was that nearly twenty

THE AIDS EMERGENCY was a test for any national leader. Addressing a disease contracted through intimate male-to-male sexual contact required a level of sophistication, tolerance, acceptance and compassion that President Reagan never displayed.

The refusal of the Reagan administration to publicly address the growing AIDS crisis brought up

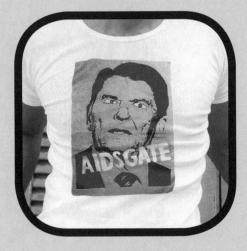

questions of conspiracy. Could the infecting agent, the HIV virus, possibly be a man-made, laboratory invention created specifically to wipe out the minorities the establishment found abhorrent? It sounded like paranoia, but the idea

percent of the assaults that were reported took place at colleges and universities. Ignorance of youth is one thing, but conservative groups had strong presences on large campuses like the main campus of Penn State University. Politics was not the only factor contributing to an anti-gay and

that thousands of people would be allowed to become ill, and die, without intervention was mind-boggling. What kind of individual would allow that to happen? Wasn't this a form of genocide?

AIDSGATE almost seemed like a plausible explanation. On T-shirts scrawled with the word across Reagan's likeness, the president's AIDS apathy was cast into the realm of scandal. The AIDSGATE T-shirt's accusation of a cover-up echoed Watergate, the blight that brought down the Nixon administration. The putrid yellow tones used on the T-shirt to tint Reagan's face mirrored Andy Warhol's "Vote McGovern" posters in which Richard Nixon's portrait was colored a fetid shade of green.

The T-shirt also displayed how much had changed since the gay movement had fought back against Anita Bryant with the "orange"-themed T-shirts. Wearing an article of clothing bearing an image like the monstrous AIDSGATE portrait of a United States president was evidence of how gays had learned to push back. ▪

anti-AIDS mindset. Popular music was another contributing factor. Songs like "One In A Million" by the band Guns N' Roses, released in 1988, were equally as influential with an impressionable portion of society. There's little chance of misinterpreting the sentiment behind the lyrics

"THIS COUNTRY IS now only emerging from two decades of turmoil during which we have tried to correct the social injustices of the past," Surgeon General C. Everret Koop stated in an address on the government's handling of AIDS in the mid-eighties. "Now will the disease of AIDS, by itself, reverse this trend of history?"

The Surgeon General was voicing a concern that gay rights groups had been fearful of since the inception of the AIDS epidemic: that the shunning of already disenfranchised minorities was going to fracture American society further. The gay community realized it would have to protect itself if this rash of violence towards homosexuals was going to continue.

that charge that "Immigrants and faggots…think they'll do as they please/Like start some min-Iran or spread some fucking disease." (In an interesting side note, Guns N' Roses was signed to Geffen Records,

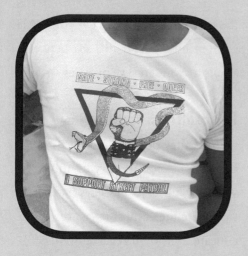

Hotlines were set up so that anyone who was a victim of gay-bashing could report the incident and receive the attention they needed. Street patrols, made up of gays and lesbians who had learned the art of self-defense, made the rounds in different cities. Taking their cue from groups like the Guardian Angels, the gay and lesbian street patrols served as neighborhood watchdogs and vigilantes.

Their T-shirts conveyed the ease with which they assumed their role as protectors of their community: The messages Don't Tread On Me and Safe Strong Free Queer conveyed that while AIDS and bigotry might have tested their mettle, nothing had weakened the community's fighting spirit. ●

the label owned by record industry executive and AIDS charity benefactor David Geffen. The band's lead singer

Axl Rose would later appear onstage with openly gay singer Elton John, whose work Rose publicly admitted

having great admiration for. Rose later cited AIDS victim Freddie Mercury of Queen as another huge influence on his career. The statements didn't come with apologies but seemed like attempts at smoothing over Rose's previous bigotry.)

In the anti-gay violence statistics reported in 1988, 17 percent were AIDS-related incidents. Without a hate crimes bill to protect them, gays and lesbians and those suffering from AIDS were at the mercy of the courts if they should try to prosecute their assailants. Those who opted not to pursue justice had ample reason to be discouraged. History had shown that the legal system wasn't exactly a friend of the gay rights movement. In the late 1980s sodomy laws still made consenting oral and anal sex between adults a crime in several states.

THE EIGHTIES WERE ending the way they began, with the homosexual community fighting with few allies. Just as gays had to initiate the earliest measures to educate their own regarding AIDS, and to secure proper health care and treatment, so the GLBT community realized it would have to protect itself if this rash of violence towards homosexuals was going to continue.

By the late 1980s, community relations with local law enforcement officers had warmed a degree or two since the days when police brutality

in bars and unwarranted harassment were regular occurrences. Yet, one incident in San Francisco on October 6, of 1989, was oddly reminiscent of those more violent days, when a squadron of nearly 100 police officers cracked down on protestors taking part in a demonstration demanding that the government allocate more money towards AIDS research. "We are here because the government has said again and again that it's OK for us to die," Mike Shriver of Act Up told the crowds and the press, resounding what had become an unfortunately familiar rallying point. "And we have had enough!" Of particular contention for AIDS activists in San Francisco was money that was being spent on a new baseball stadium, funds which they felt would be better spent saving lives. A banner reading "Baseball = Death" and chants of "We're here, we're queer and we're not playing baseball!" announced the demonstrators' objections. Outlines of corpses, representing AIDS victims, were spray-painted on the street by some protestors, while others blocked traffic. Police responded to this commandeering of the city's infrastructure with force when one of the individuals participating in the demonstration allegedly assaulted an officer. Chants of "This is not Tiananmen Square!" began to rise from the crowd. By the time the "volatile five hour demonstration,"

BY THE END of the 1980s, the gay community's relation with local law enforcement officers had warmed a degree or two since the days when police brutality in bars and unwarranted harassment were regular occurrences. Yet, one incident in San Francisco on October 6, 1989, was oddly reminiscent of those more violent days. A squadron of nearly

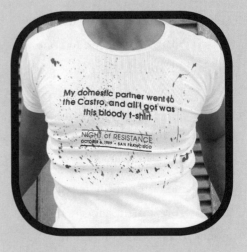

100 police officers cracked down on protestors taking part in a demonstration demanding that the government allocate more money towards AIDS research. "We are here because the government has said again and again that it's OK for us

had ended—as described by the San Francisco Examiner the next day— between fifty and sixty protestors were arrested, and one hospitalized.

IN THE DAYS that followed, participants in the October 6th demonstration were still reeling from the outcome of the event. T-

to die," Mike Shriver of Act Up told the crowds and the press, resounding what had become an unfortunately familiar rallying point. Of particular contention for AIDS activists in San Francisco was money that was being spent on a new baseball stadium, funds which they felt would be better spent saving lives. A banner reading "Baseball = Death" and chants of "We're here, we're queer and we're not playing baseball!" announced the demonstrators' objections. Outlines of corpses, representing AIDS victims, were spray-painted on the street, while some protestors blocked traffic. Police responded to this commandeering of the city's infrastructure with force when one of the individuals participating in the demonstration allegedly assaulted an officer. Chants of "This is not Tiananmen Square!" began to rise from the crowd. By the time the "volatile five hour demonstration," had ended—as described by the *San Francisco Examiner* the next day—between fifty and sixty protestors were arrested, and one hospitalized. ▪

shirts were printed to immortalize what was being called The Night of Resistance. White shirts splattered with red paint bore the inscription "My domestic partner went to the Castro, and all I got was this bloody T-shirt."

The demonstration in San

Francisco was part of a coordinated national effort by members of Act Up, with twenty similar actions occurring in other cities that day. Eighty protestors were arrested in Los Angeles.

That same weekend, the Names Project displayed the AIDS quilt in Washington, D.C.

AS THE TWENTIETH ANNIVERSARY

of the Stonewall Riots was observed in June of 1989, the gay and lesbian community looked back over its battle for equality of the last two decades with a hopeful eye on the future but a watchful eye on the past. The advances and triumphs the movement had enjoyed were tempered by the ongoing AIDS crisis and awareness that their conservative adversaries were finding new ways to dismantle their progress. The funding of work by photographer Robert Mapplethorpe by the National Endowment for the Arts was held up as an example by some anti-gay factions to show how homosexuals were ruining the moral fiber of America and using taxpayers' dollars to boot. Mapplethorpe's portraits of gay men engaging in acts of sadomasochism were cast as symbolic of the whole of the gay aesthetic as politicians like Jesse Helms used the photographer's NEA grant as a platform to attack homosexuals. The warning in the

condemnations by politicians was implicit. This is the kind of imagery homosexuals will fill our museums and office halls with if their agenda is not beaten back. The politics of censorship and what is or what is not considered pornographic were the steamy subjects of an even more heated debate in Washington. The government responded to the controversial photography and the hysteria caused by the NEA's funding of it by writing a clause that restricted any future grant money from finding its way into the hands of any artists who would produce work that included "sadomasochistic or homoerotic" content.

It seemed like a big solution to a small problem. If the images were so offensive to Helms and to others, why did they just not look at them? But this was an easier way to demonize homosexuals and a more dramatic and effective way to rally future voters in the process.

For their part, gays and lesbians had also been taking a grassroots approach, encouraging homosexuals to come out while educating the rest of society. Exposure was proving to be an effective means of communication as was familiarity. Whether it was because of the irreversible changes AIDS had brought about, or the continued denial of equal rights, homosexuals spoke up and came

ONE EARLY SELF-APPOINTED spokesperson for the AIDS movement was San Francisco's Bobbi Campbell. In 1983 Campbell bravely appeared in public wearing a T-shirt that identified him as the "AIDS POSTER BOY." By putting a face on the disease Bobbi Campbell knew he was no longer just another statistic. Even the dead were more easily counted than considered.

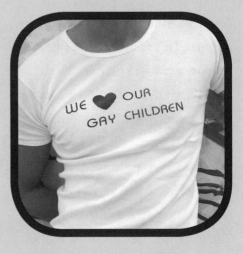

But people like Campbell were not just numbers of infections or types of illnesses

out in the 1980s in the thousands. At the time of the Stonewall Riots in 1969 there were only 50 gay and lesbian organizations in the United States. By 1989 there were over 3000 such groups.

THERE WERE ALSO a growing number of organizations that championed the GLBT community's cause that were not necessarily gay exclusive. AIDS-related fundraising groups like AmFAR, food services

or charts chronicling blood work: They were friends, brothers, sisters, sons, daughters, fathers, mothers, uncles, aunts and lifetime companions.

The bravery enacted and suffering endured by those battling AIDS wasn't limited to those with the illness. As the acronym for the group PFLAG suggests, supportive parents, family and friends of lesbians and gays were the proud founders of the organization in 1981. Wearing a T-shirt proclaiming such support was often as dangerous for the concerned family and friends of AIDS patients as it was for the infected person. This type of admission was its own form of coming out, and just as the emergence from the closet of homosexuals had done, so the stepping forward of parents, family and friends of gays and lesbians to stand by their loved ones increased visibility and sent a message of unity and compassion. ∎

like Project Angel Food in Los Angeles and outreach programs like HERO in Baltimore were increasing in number. PFLAG, was founded in 1981 by, as its acronym implies, supportive parents, family and friends of lesbians and gays.

Families, and the role of GLBT individuals in them, would figure prominently in the push for rights in the next decade.

"

I wore one of those "Read My Lips" shirts to my high school, junior year, thinking I would really freak out the student body, but by that point all of the kids thought I was so weird that it didn't really phase anyone. But I still thought it was revolutionary!"

KAIA WILSON

musician from The Butchies and Team Dresch

"

CHAPTER FOUR: 1990 to 1999

The New Gay Nineties

THE LINE, "YOU BETTER WORK," as flung at Jan Brady by her guidance counselor in the film *A Very Brady Sequel* showed the progress GLBT rights and activist proponents had made in pop culture by 1996. Delivered by RuPaul, the drag queen playing the role of guidance counselor, "You better work" was the It Phrase of the early nineties, taken from the performer's club hit, "Supermodel." That an element of camp was front and center in a mainstream movie release—and that it came without any secret nudges or winks indecipherable to those who weren't in the know—was a major development in American culture.

"DON'T PANIC!" was a fitting aphorism, and affirmation, for the GLBT community in the last decade of the century. Emotions were raw. The AIDS crisis was entering its second decade and a cure was nowhere in sight. Fears were confirmed for those battling the disease. This was going to be a long fight. The same could be said of the struggle for equality, considering the appearance of anti-gay initiatives such as California's AB 101,

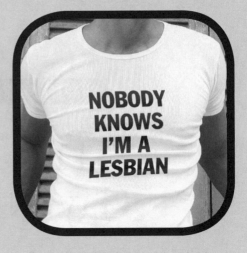

There were parts of the community who felt this was not the right kind of progress, though: If anything the "mascot mentality" which treated gays and lesbians as harmless caricatures lampooning their own images only reinforced a stereotype. The 1990s would see more of this in NBC's sitcom *Will & Grace* in which quick-witted banter was never in short supply, but expressions of homosexual love were absent for

Colorado's Amendment 2 and Oregon's Proposition 9.

By once again turning a taboo into something mundane, the creators of the "Don't Panic" line of T-shirts, hats, stickers and coffee mugs were helping their fellow GLBT community members increase their visibility and hopefully defuse bigotry at the same time. In order to ensure that such legislation would not pass, GLBT leaders called for their constituents to be more visible. And what could be more visible than a shirt that identified the wearer as gay or lesbian, complete with the use of the first person pronoun? The appearance of the referential "I" on nationally distributed GLBT-themed shirts and products, such as those offered by Don't Panic, was proof that visibility had a cumulative effect. ∎

several seasons. But the very idea that gay and lesbian main characters would anchor shows in prime time was unthinkable ten years earlier.

Still gays and lesbians were allowed to entertain the American public, but they continued to be denied basic human rights in the 1990s. Issues that had faced the community since the inception of the rights movement stubbornly continued to cause

problems. Denial of housing and employment rights was being chipped away at, while progress was made in AIDS awareness and funding for treatments and research for the disease.

Added to the list of rights gays and lesbians were publicly fighting to secure were the right to serve in the military and, among a growing number of GLBT persons in committed relationships, the right to marry.

The community saw its power increase early in the nineties when a presidential candidate openly embraced gays and lesbians with a "place at the table" welcome. The call for equality from the homosexual rights activists' movement was finally being heard.

EVIDENCE OF the ways AIDS had seeped into the American landscape was everywhere, from newspaper sections devoted to the weekly policies, medical news, fund-raisers and death tolls, to a line of Hallmark cards called "Between You and Me." The greeting card company was capitalizing on the often-repeated warning that going to bed with someone meant a person was essentially climbing into the sheets with all of their lover's previous partners. Cards were printed to broach the delicate topic with messages that read, "Let's

talk before we go any further."

There were small signs that progress was being made at least in how AIDS and persons with AIDS and HIV were perceived in the 1990s. Two of the most famous AIDS patients of the 1980s were responsible for helping to initiate a change, albeit a slow one, in the public's perception about the disease. By coming out with the truth of their HIV status, both gay actor Rock Hudson and straight middle school student Ryan White had put a face on the illness, one recognized and the other unknown, stripping AIDS of its anonymity. For the millions of Americans who thought AIDS was only a gay disease, and who had thought gays were a

group far removed from their world, the image of a brave, straight teenager and a former screen idol both battling for their lives was extremely powerful. AmFAR, the American Foundation for AIDS Research, was founded by actress Elizabeth Taylor, Dr. Michael Gottlieb, and Dr. Mathilde Krim shortly before Hudson's death in 1985, and the Ryan White Care Act, was passed by Congress after White's death in 1990. The charity and the federal program helped to educate, fund and finance AIDS-related services to victims and their families. But they also helped to shift—at least a portion of—the public's sentiment. By the time MTV's *Real World* reality show featured AIDS-stricken cast member

Pedro Zamora, a new generation of American youth were growing up in an atmosphere where discussion of the disease, and of homosexuality, was often encouraged. It was radically different than the tone the Reagan and Bush era policy had established on the disease or toward gays in general.

The film and television industries continued filling the void created by the government's policy of silence on AIDS. Daniel Harris, author of *The Rise and Fall Of Gay Culture* proposed that it was this negligence that turned Hollywood and the entertainment industry into defacto AIDS fundraisers and cultural ambassadors, as celebrities were routinely seen hosting charity events and cozying up to famous gays and lesbians. In its refusal to address the AIDS crisis the Reagan-Bush administration had, either intentionally or inadvertently, further knotted the issue of AIDS with the gay rights issue. The worlds of arts and entertainment were gutted by the disease and celebrities were stepping up to honor those they'd worked with and lost, and to also help raise money for research and patient services to make sure such a holocaust never occurred again. In doing so they also helped establish a more understanding and compassionate tone toward AIDS and also gays and lesbians.

There was evidence that the approach was working. On television the use of gay and lesbian characters

as the brunt or punch line of a joke was becoming less acceptable. But advertisers whose commercials ran during television shows featuring normal representations of homosexuals often panicked and pulled their ads off the air rather than face consumer backlashes or boycotts.

BOTH ABC'S *thirtysomething*

and NBC's *L.A. Law* lost advertising revenue; the former for showing two men in bed together and the latter for showing two women sharing a kiss. *Dynasty* had a gay character in the mid-eighties, but the show's portrayal had more interest in scandal and ratings than in achieving any serious social relevance. *An Early Frost* dealt

responsibly with the AIDS crisis in 1985, shockingly early considering the attitude in Hollywood and the nation at the time.

On talk shows, Oprah Winfrey continued in the steps of Phil Donahue—the format's pioneer when it came to discussing taboo topics intelligently and sympathetically—and routinely devoted her show to gay, lesbian and AIDS-related topics. Winfrey introduced millions of Americans to the very real heartbreak the illness caused for those suffering with it, as well as for their families. Countless gays and lesbians had lived with the fear of being disowned by their loved ones if they came out, and

THE EARLY 1990S saw California's GLBT community fighting for Assembly Bill 101, or simply AB 101, a law that would have given equal rights in matters of employment and housing to persons of all sexual orientations, identified as "heterosexual, homosexual or bisexual" in the language of the law. On the T-shirts, which were made to bring public awareness to the community's

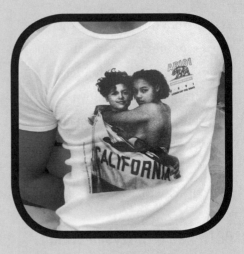

fight, the flag scarcely covered the bare lesbians' and gay men's bodies featured in the graphics, just as the existing law barely protected their rights.

The expressions on the faces of the couples were unflinching as they looked out at the viewer. This was a new level of putting very real faces—and bodies—on an issue. These were not nationally famous persons lending their faces to a cause;

AIDS only added to the poignancy of the dynamic. A growing number of families were beginning to embrace their homosexual offspring as AIDS, and anti-gay sentiment forced them to confront their own prejudices.

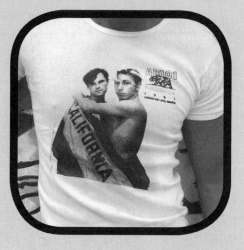

these were neighbors, co-workers, sons, daughters, family members. In other words, the message of the shirt was that AB 101 and other laws that denied GLBT rights had a direct impact on people that we knew. And while this had been the message the rights movement had been sending for decades, the indifference that the community had suffered during the AIDS crisis of the 1980s coupled with HRC's "National Coming Out" campaign created an environment and mindset of urgency from which individuals were stepping forward. Like Bobbie Campbell's "AIDS Poster Boy" declaration, the AB 101 shirts put a face on an issue. Numbers and statistics could be passed over, but it was harder to deflect a person's gaze. ∎

THE STRUGGLE ALSO continued to get GLBT rights laws on the books. Despite the rise of gay-bashing and AIDS-related violence in the last half of the eighties there were still no hate crime laws in place to

protect minorities from malicious bigotry. Likewise employers could refuse to hire or could dismiss employees on the basis of their sexual orientation, just as housing could be denied for the same reason in many parts of the United States.

CALIFORNIA'S GOVERNOR, Pete

Wilson, stunned voters in 1991 when he vetoed Assembly Bill 101, or AB101, a bill that would've given equal rights in matters of employment and housing to persons of all sexual orientations, identified as "heterosexual, homosexual or bisexual" in the language of the bill. Once word spread about Wilson's axing of the proposed bill, it

didn't take long for mobs of angry protestors to swarm the streets of San Francisco. Demonstrators smashed windows, set fires and overran the city's municipal Old State Building as a chant of "Queers bash back!" went up from the crowd. Approximately $250,000 worth of damage had occurred by the time the rioting stopped. With polls by the media finding widespread support for AB 101, with 2 to 1 potential voters questioned speaking in favor of the bill, Wilson's veto was a shock to many Californians. A similar bill had been struck down in 1984 by then-Governor Deukmejian. In the aftermath of Wilson's veto Steven Merksamer, an aid to Deukmejian's

administration, told the *San Francisco Chronicle* "The policy basis for the veto [of AB101] is that one's sexual orientation is a private matter and should not be elevated to the status of a civil right." It was an argument the gay rights movement had been hearing for years, but over the last three decades gays and lesbians had reached a point of no return in their demand for equal rights—and this was not going to deter them.

EQUALITY MIGHT HAVE remained elusive, yet there was some progress and some cause for hope. The United States had removed the "sexual deviancy" stipulation that had previously barred entry into the country for gay and lesbian visitors in 1990 even if domestic policies, like Governor Wilson's veto of California's AB101, seemed to suggest the country was moving backwards. There was more evidence that the California assembly bill was not an isolated incident. That same year a group calling itself Colorado for Family Values started working to place an initiative that would become known as Amendment 2 on the state's election ballots. If passed, Amendment 2 would allow the dismissal of gays, lesbians and bisexuals from employment, arguing that such protection would amount to "special rights" for the individual since no such law protected

ON SEPTEMBER 30, 1991, mobs chanting "Queers bash back!" overran San Francisco's Old State Building. Windows were smashed and fires were set causing $250,000 in damages before the rioting stopped. The thrust behind the disruptive action was Governor Pete Wilson's vetoing of California Assembly Bill 101. Once word spread about Wilson's axing of the proposed bill, it didn't take long for throngs of angry protestors to swarm the streets of San Francisco.

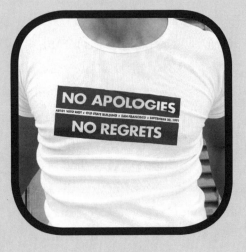

The familiar, unrepentant message "NO APOLOGIES NO REGRETS" which demonstrators had used after the Dan White verdict, for example, memorialized the events of the "AB 101 Veto Riot." ●

heterosexuals from being fired or barred from a job based upon their sexual orientation. In November of 1992, Colorado's citizens voted in favor of Amendment 2 by a margin of 6 percent; 53.4% were in favor, 46.6% were opposed. It would take four years, and the intervention of the United States Supreme Court, but Amendment 2 was eventually repealed. (The Supreme Court found in a ruling of 6 votes to 3 that the Colorado anti-gay amendment infringed upon the Equal Protection Clause of the Fourteenth Amendment of the United States Constitution.)

In addition to the Colorado ballot, voters in Oregon were asked to consider Proposition 9 in 1992.

The language of Proposition 9 would have made "disruptive" behavior by gay and lesbian employees grounds for termination, though it didn't describe what constituted that type of behavior. It also barred the use of any public money for distribution of any materials that might include homosexuals or homosexual behavior to anyone under the age of eighteen. The initiative was defeated, but gays and lesbians were seeing they had a pernicious fight on their hands. Rather than retreat, gay rights activists became more determined than ever to make changes that were lasting.

AS A POLITICAL FORCE the GLBT community had grown stronger

TURNING THE WORDS spoken by President George H. W. Bush as part of his 1988 campaign promise into a different kind of platform, "READ MY LIPS," showed how the gay and lesbian movement's confidence continued to grow, and that its wit certainly hadn't withered. Like the "Every Kiss is a Revolution" shirt, the "LIPS" shirt dared the public to look at a different

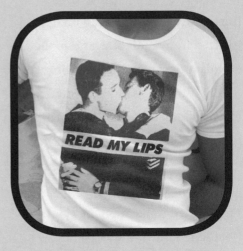

expression of love. By using the aesthetic of artist Barbara Kruger, whose photos had urgent bulletins typed across them, the shirts also delivered their message in high style. ●

and louder than ever at the onset of the 1990s. The AIDS epidemic had made gays and lesbians more visible in meetings and hearings in which policy was decided. The pressure from gay groups on drug companies, the U.S. government and even the media had brought about

many changes in the late eighties in the way the GLBT topics were addressed. Elected officials were learning that in order to effectively reach out to their GLBT constituents they needed liaisons from that community on their staffs. In New York both city Mayor Ed Koch and state Governor Mario Cuomo had staffers who were not heterosexual as a means to reach out to the GLBT community. A *New York Times* article from 1989 acknowledged the growing sympathetic tone of newspapers, magazines and other forms of media in addressing gay and lesbian issues. Sensationalist headlines smearing homosexuals, like the one from the *National Enquirer* circa 1980, were beginning to disappear along with slanderous, hateful terms like faggot or fag. In fact by the time the third March on Washington for gay and lesbian rights took place in April of 1993, the coverage in the *Washington Post* in the days leading up to the event rang with the welcoming tone of a homecoming. Articles ranged from detailing how the city's Metro rail system was preparing for the increase in riders to the coming out stories of military personnel to a new type of Christian theology that found evidence of homosexuality in the Bible; "Was Hero David in Goliath Tale Homosexual?" one headline asked. Photos in the paper depicted happy homosexual

THE GLBT MOVEMENT had been taking their fight to the streets for over twenty years by the time the first public display of the AIDS Quilt occurred. But the T-shirts commemorating the quilt's viewings were a way to take the message of the quilt to those who might not have seen it. Like the patches from the quilt itself, these T-shirts memorialized the

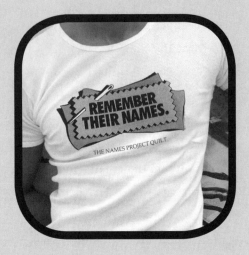

victims of the disease. "Remember Their Names" implored society to be mindful of the lives, not simply the numbers that were lost. "Because We Won't Let Them Forget" honored the global victims and served as a reminder that AIDS went beyond social and international boundaries. It was not simply the concern of gays, IV drug users, Haitians, minorities or even Americans for that matter. It was everyone's concern. ■

144

couples on one page, earnest young rights' activists on another. The *Post's* editorialists expressed strong support for the march, with writer Linda Keen reminding readers that "gays have been thrown into concentration camps, thrown out of their families, fired from jobs, banished from churches, beaten and murdered, denied the right to marry and regarded as practically nonexistent because of the common assumption that everyone is straight."

The tone of the piece was all but an endorsement for gay and lesbian equality, firmly planted in the pages of one of the most respected media outlets in the country.

In the final days before the April 25th March on Washington the *Post* continued its in-depth look at the very personal struggle of the GLBT community as faced by gays, lesbians and their families. "Many Parents of Gays Travel A Rough Road," sympathized a headline for a story about a family who were members of PFLAG and who would be marching with their gay son in the weekend's rally.

On the morning of the march, April 25th, the *Washington Post's* front page focused on the gay rights rally taking place in the city that day. An article about the "qualified tolerance" towards gays and lesbians in the metropolitan D.C. area announced that the

newspaper's poll found residents in and near the nation's capital to be more accepting of homosexuals than the rest of the country, "up to a point." Equal rights for gays and lesbians in matters of housing and employment were favored while issues pertaining to gay marriage and gay adoption seemed to be where most Americans drew the line.

The march and the publicity it generated for the plight and fight for equality among America's GLBT citizens was invaluable. The country was talking about gay rights issues, and more importantly it appeared to be listening to what proponents of GLBT equality were saying. "Discrimination against gays has finally won the attention of the nation, and the president of the United States has become a champion of ending that discrimination," Keen wrote in her *Post* editorial, drawing a distinction between the hosting administration in the White House for this march and the previous occupants.

THERE WAS SOMETHING poetic that the march on Washington for gay and lesbian equality in April of 1993 should take place within the first 100 days of the presidential administration of William Jefferson Clinton. As a candidate Clinton had established an early tone of inclusiveness when,

speaking before a gathering of 600 gay and lesbian supporters, he promised his administration would work towards an end to anti-gay discrimination. "Every day that we discriminate, that we hate, that we refuse to avail ourselves of the potential of any group of Americans, we are all less than we ought to be," Clinton told the crowd. Acknowledging the divisive tactics of the administration he was hoping to unseat, he continued on, saying, "This country is being killed by people who try to break us down, and tear us up and make us little when we have to be big."

The most surprising part of his speech came when the presidential candidate said he would "[give] up [his] race for the White House and everything else," if by the "wave of [his] arm" he could wipe out HIV and take away the suffering of AIDS patients. "Clinton Chokes up Over AIDS," ran a headline in the *San Francisco Chronicle* on May 19, 1992, the day after the speech was given.

The welcoming tone was refreshing and was in the opinions of many the correct interpretation of family values. Family values was one of the recurring themes and part of the platform the Bush/Quayle Republican presidential ticket had run its campaign on, though the Republican definition of "family" excluded gays and lesbians. T-shirts

and bumper stickers with messages reading "Hate is Not a Family Value!" and "I'm gay and my family values me" poked holes in the false wholesomeness of the Republicans' moralizing. Clinton's "place at the table" policy towards the GLBT community was actualized when, after his election into office, he appointed Roberta Achtenberg as Assistant Secretary for Fair Housing and Equal Opportunity. Achtenberg was the first out lesbian to ever achieve such a high government post. Other openly gay and lesbian individuals were part of President Clinton's administration. It was heartening for the gay rights movement to have such a friendly ally, and Clinton's promise to work towards lifting the ban on gays in the military seemed like it could actually become a reality.

IN MANY WAYS it could be argued that the gay rights movement has part of its roots in the military's policy of excluding gays and lesbians from serving in the armed forces. During the First World War military law relied upon the infamous Article 93 from the United States' Articles of War, which "prohibited assault with the intent to commit sodomy," as a way to enforce and punish homosexual activity. After the war, the act of sodomy, whether forced or by consent, was added to

the military's law as a punishable crime. The screening process that the armed forces employed during World War II was designed to single out men who bore physical traits the military's medical experts believed denoted a homosexual male. Known as the "stigmata of degeneration," the criteria that tipped off the doctors that the man they were examining was most likely gay included "sloping shoulders, broad hips, and an absence of...facial and body hair." A questionnaire implemented with help from the American Psychiatric Association's Military Mobilization Committee was used to help identify homosexual tendencies that weren't immediately visible.

Numerous gay men and lesbians served in the military during World War II, and their discovery of one another, in such large numbers has been credited with helping to establish the large coastal gay communities in postwar New York and San Francisco. After the war, the Army briefly changed its stance, making allowances for honorable discharges of homosexuals, but in 1949 the Department of Defense declared that "Homosexual personnel, irrespective of sex, should not be permitted to serve in any branch of the Armed Services in any capacity, and prompt separation of known homosexuals from the Armed Forces be made mandatory."

Four years later in 1953 General-now-President Eisenhower signed into law Executive Order 10450, which identified "sexual perversion" as a cause for a federal worker's employment termination.

Executive Order 10450 was responsible for the firing of stalwart activist Frank Kameny. Kameny went on to found the Washington, D.C. chapter of the early gay rights group, The Mattachine Society, after the reason for the loss of his job resulted in a very public outing. The former army astronomer and World War II veteran fought arduously for the overturning of the order that cost him his career.

The Clinton Administration's determination to remove the ban on gays and lesbians serving in the military was looked upon as a watershed moment in gay rights history. It not only addressed one of the most significant moves towards gay equality in American history, but it was the first time an American president spoke so openly and inclusively, and without prejudice, about homosexuality. The days of being discharged for being gay or lesbian in the armed forces would come to an end.

The proposal failed miserably. Citing the alleged incompatibility of homosexuality with military service, experts came forth to discredit Clinton's intention of lifting the ban;

however a 1992 survey conducted by the Center for the Study of Sexual Minorities in the Military found that army personnel did not see gay or lesbian soldiers as an imminent threat. When asked if they felt that openly gay and lesbian soldiers would attempt to seduce them, the majority of the presumably heterosexual male and female service personnel who were asked, answered that they "disagreed" or "strongly disagreed" with that question.

The resulting compromise, "Don't Ask, Don't Tell, Don't Harass, Don't Pursue" allowed gays and lesbians to stay in the military so long as they did not talk about their orientation to other soldiers or engage in sexual activity with other soldiers of the same sex. It essentially amounted to nothing more than keeping gays in the closet. Forced into the compromise by an increasingly antagonistic Congress, the president found himself accused of abandoning the gay community that had helped put him in office. "Don't Ask, Don't Tell" continued the employment discrimination the military had exacted for decades. At its worst it essentially denied the contributions made by scores of gays and lesbians who had fought and died for their country. As Kameny would say of decorated homosexual soldiers years after Clinton's failed attempts at lifting

the ban: "To eliminate them from the Armed Services is to lower the quality of the Armed Services, [and] is to give aid and comfort to the enemies of our country [and that] is the definition of treason in Article 3, Section 3." It was an extreme remark. But in the removal of service personnel who were, in some cases, exemplary, simply because of their sexual orientation, the military was indeed weakening its ranks.

THE MILITARY REMAINED, as

Kameny later pointed out, one of the final battlegrounds for gay and lesbian equality as the Gay Nineties took shape. The other points of contention and strife—the Employment Non-Discrimination Act, a hate crimes bill, and same-sex marriage—were part of an enduring, and seemingly ingrained, code of cultural bigotry.

Visibility had been an important component of the gay rights movement ever since Harry Hay, Frank Kameny, Del Martin, Phyllis Lyon and other early activists first took to the streets carrying picket signs denouncing anti-gay discrimination. Awareness was necessary to foster understanding. Showing the heterosexual community that the GLBT community was their community— their neighbors, coworkers, fellow parishioners, teammates, teachers,

family members, sons, daughters and even their mothers and fathers—was essential. Marginalizing a minority became more difficult when the minority in question had a face that you knew, and possibly even loved.

For the gay rights movement education was the best way to battle ignorance, no matter the decade or the issue. But a steadfast refusal to move even towards the middle ground became the hallmark of groups opposing GLBT equality. The gay-friendlier tone that the Clinton presidency set wasn't without its opponents. Organizations like the Moral Majority and Family Research Council continued with anti-gay rhetoric based on a refusal to acknowledge homosexuality as a natural part of the human condition. When met with that sort of obstinacy, the response from gay rights activists in the nineties ranged from the humorous, like the Lesbian Avengers' "We Recruit!" riffing on the long-held assertion that homosexuals had to convert heterosexuals, to the unwavering Queer Nation's T-shirt that blasted "Get Used To It!"

A YEAR AFTER President Clinton had attempted to lift the ban on gays in the military, Massachusetts Senator Edward Kennedy proposed Senate Bill 2238. The Employment Non-Discrimination Act or ENDA,

IN A NOD to the success of the Lavender Menace T-shirts and group action early in the call for equal gay and lesbian rights, a new generation of lesbian activists was adding a unique voice to the era's "we're here, get used to it" mantra. Using the image of a black 8-ball-like bomb with a lit and crackling fuse, the Lesbian Avengers' T-shirts relied on wit as well as nerve

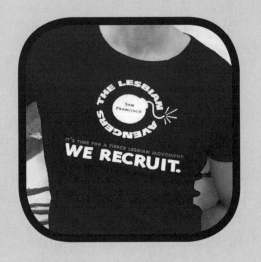

as Senator Kennedy's bill was also known, would have included sexual orientation as one of the reasons for which an individual could not be refused employment. (Matters of race, color, religion, national origin, age and handicap were already

protected.) Brought to the table in June of 1994 and backed by 28 other senators, the ENDA stated in its findings "an individual's sexual orientation bears no relationship to the individual's ability to contribute fully to the economic and civil life

154

to state their mission. The Lesbian Avenger Tees turned the anti-gay movement's propaganda on itself. Slogans like "We Recruit!" pointed out the ridiculousness of opponents' arguments against allowing gay and lesbian rights equality. Like Queer Nation, which reclaimed the formerly derisive term and in doing so robbed it of its venom, the Avengers' T-shirts used a humorous approach that simultaneously deflected the confrontations they threatened to ignite. The escalating "culture wars" pitted Americans against each other over a number of issues. And at a time when tensions were taut on both sides of the gay rights equality debate, the Lesbian Avengers managed to add some refreshing levity without compromising their stance. ∎

of society." The language of the bill was revolutionary. Democratic and even some Republican members of the United States Congress were openly admitting that "historically, American society has tended to isolate, stigmatize, and persecute gay men, lesbians, and bisexuals," and arguing that these same individuals had "historically been excluded from full participation in the political process," as well as "subjected to purposeful unequal treatment based on characteristics

not indicative of their ability to participate or contribute to society."

The bill would have granted an exemption to religious groups, the armed forces and small businesses with less than fifteen employees.

Nearly a year and a half after it was introduced the ENDA was still stalled in the political pipeline. The Republican Congress was adamantly opposed to its passing. In October of 1995 President Clinton sent a letter to the bill's sponsor, Senator Kennedy, expressing his support. In the letter, the president flatly said of the employment discrimination faced by gays, lesbians and bisexuals, "This is wrong."

Clinton's endorsement, like the ENDA legislation itself, was worded so as to specifically address the issue of "special rights" versus equal rights for homosexuals. His letter pointed out that a person could still be fired solely because of their sexual orientation in forty-one states, and if terminated for that reason an individual would "have no legal recourse, in either state or Federal courts."

Polls showed that the majority of Americans did not approve of this type of discrimination of gays and lesbians, but the same surveys demonstrated that most Americans were unaware that homosexuals were not already privy to this type of employment protection. As openly

gay Massachusetts Representative Barney Frank told the *New York Times*, "The right wing says what [gays and supporters of the ENDA] want is special rights, [...] because they assume we already have the protections we are asking for, and so must be asking for something more."

If opponents of gay rights were going to focus on the use of the word "special" as regards what homosexuals wanted, gay rights leaders were determined to remove the implications of exclusivity which that word implied and strongly emphasize what the GLBT community had always been asking for—equality. The Human Rights Campaign's new executive director, Elizabeth Birch, branded the organization and to a larger degree the rights movement as a whole with a fresh logo in 1995. The equal sign as it appeared on bumper stickers, T-shirts and official stationary was an easily recognizable symbol. It required no insider information. Its meaning was obvious.

THE PROGRESS gays and lesbians made in the first half of the 1990s was in part because of the validation of gay rights activists' efforts by President Clinton's acknowledgment that the discrimination homosexuals suffered had to stop. American politicians and American society, which had long focused on the

otherness of gays, were displaying a new, yet cautious openness. While Americans were not fully ready to embrace homosexuals as being the same, or equal, they were becoming more aware of the similarities in their life experiences.

The Democratic Party, as led by Clinton, was establishing itself as the party of inclusion. In a nod to both the proposed Employment Non-Discrimination Act as well as the need for a Hate Crimes bill that protected homosexuals, lesbians, bisexuals and transgender individuals, the Platform for the Democratic Party's Convention in 1996 stated, "Today's Democratic Party knows we must renew our efforts to stamp out

discrimination and hatred of every kind, wherever and whenever we see it…" The party was correct, if not a little self-congratulatory in saying "We continue to lead the fight to end discrimination on the basis of race, gender, religion, age, ethnicity, disability, and sexual orientation" and that they "support[ed] continued efforts, like the Employment Non-Discrimination Act, to end discrimination against gay men and lesbians[.]"

Despite the declaration of this mission statement, a few short months after the Democratic Convention that year, and a month before the presidential elections, the passage of the ENDA was deferred yet

again. Over twenty years had passed since New York's Bella Abzug had proposed the first bill that would have given homosexuals federal rights. The bill that Senator Kennedy and his colleagues had drafted in 1994 had advanced further than any other piece of Federal gay rights legislation. The President of the United States had endorsed it. Polls showed Americans were against discrimination. But those who opposed the ENDA were relying on an argument that anti-gay factions had used so effectively in the past; only this time at issue was not whether homosexuals should be teachers, as it was in the case of Dade County, Florida, in the seventies: Conservative Republicans

in the House of Representatives were sounding the alarm, stirring up anxieties over the possibility that Boy Scouts and Girl Scouts would be forced to accept a homosexual leader without legal recourse. Homosexual teachers only had dominion over a classroom whereas homosexual scout leaders would be in very close quarters with children on overnight outings. The old, insulting charge that gay and lesbian adults could not be trusted stewards of their own sexuality—and in this case casting them as pedophiles—was once again used as a scare tactic.

The ENDA failed to pass by one vote. The scout issue was not the sole basis for the ENDA's defeat, but it

TEN YEARS EARLIER, the average gay man, let alone the average person had little idea what a T-Cell was. But as awareness of how AIDS attacked the body spread in the medical community, newly diagnosed patients as well as those already infected, discussed T-Cell counts—the number of disease-fighting cells formed in the thymus—anxiously. Drugs that fought

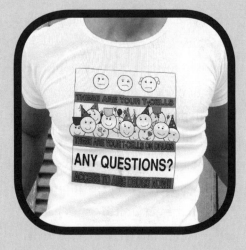

AIDS helped the body increase its immunity-fighting T-cells and the These Are Your T-Cells T-shirt relied on the old "This is your brain, this is your brain on drugs, any questions" public service announcement format to spread the word on the need for effective AIDS drug availability. The tone of the shirt is remarkably upbeat and indicative of the shift in the nineties toward a less militant means of delivering messages. ■

160

showed that conservatives could still rely on ignorance as a galvanizing political tool even in the country's growing climate of acceptance.

BUT GAY RIGHTS LEADERS learned that it wasn't just conservatives who could use their interests against them for political gain. In 1996 President Clinton stunned gays and lesbians by his support of the Defense of Marriage Act, legislation that would not recognize same-sex marriages on an interstate basis. While there was nothing on the books that technically legitimized same sex marriage in any state, recognition of domestic partnerships was growing. Corporations were beginning to offer health insurance benefits to their employees' same-sex partners and cities like San Francisco were officially recognizing domestic partnerships. Hawaiians were debating the constitutionality of not allowing same-sex partners to marry. Clinton's signing of the Defense of Marriage Act prevented conservatives from casting him as too liberal, yet many gay activists felt it was reminiscent of the type of political abandoning the movement had witnessed from others who'd sought their favor, and votes, decades earlier.

Still there was no denying that Clinton's was the most inclusive administration the Oval Office had ever housed. Gay activists were

A TACTIC THE OPPOSITION to GLBT equality began using was to focus on the work of gay artists. The late 80s and early 90s saw right-wing critics, suddenly experts in art and aesthetics, lining up to denounce the work of artists like photographer Robert Mapplethorpe as immoral and even pornographic. Government funding for gay artists, and the arts in general,

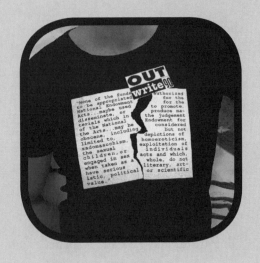

invited to the White House, gay couples were introduced to the President as partners at holiday parties, and gay symbols like the rainbow flag were actually displayed in government buildings. Gays went from feeling like the perennial outsiders to being welcome guests. The 1990s had seen the gay rights movement gain steady momentum. The pall that had hung over the decade's arrival—with the Mapplethorpe controversy, the state-proposed anti-

162

through the National Endowment for the Arts was threatened.

The OUTwrite conference in San Francisco groomed works in progress by gay and lesbian writers. The T-shirt commemorating the workshops thumbed its nose at the government's ruling that public monies would not be used towards the creation or promotion or distribution of any materials that might contain "homoerotic" themes. The sandwiching of homosexuality between "sadomasochism" and "sexual exploitation of children" provided some insight into how the authors of the ruling viewed homosexuality.

The T-shirt's depiction of the document being torn in two spoke to the writing program's refusal to bow to political pressure or censorship. ■

gay legislation and the ongoing AIDS crisis—had been lifting.

VISIBILITY WAS INDEED

leading to familiarity, and if not acceptance then at least discussion. As one T-shirt from a New York Pride celebration reminded the gay and lesbian community, "Every kiss is a revolution." Each time heterosexuals were confronted with the image that homosexuals were the same as them, except for how they were inclined to express their love, it eroded the

AS THIS SHIRT CONVEYED, through images of four same-sex couples expressing their love, each exposure the general public had to such expressions was an opportunity to wear down ignorance and prejudice; such public displays of affection eroded the otherness that was so often associated with gays and lesbians. The more the world was presented with images of

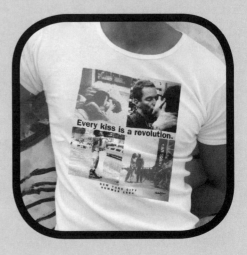

GLBT individuals without exception the likelihood of them appearing shocking or foreign was lessened, not only among heterosexuals but also for those sexual minorities who might have had trouble coming to terms with their orientation. ●

otherness that was so often associated with gays and lesbians. The more the straight world was presented with images of GLBT individuals without

exception, even if the depictions were only in the media, the likelihood of them appearing foreign lessened. And there were plenty of images in the

nineties. Tom Hanks won an Oscar for playing a gay man dying with AIDS (though the film *Philadelphia* skirted the intimacy of his character's relationship with his partner.) Lesbian chic was the stuff of media "hot lists." Sandra Bernhardt's depiction of fluid sexuality forced people to think beyond labels. Melissa Etheridge and k.d. lang were topping the *Billboard* charts. Riot Grrrls, the punk-fueled movement, was the soundtrack for lesbians and feminists coming together to make noise for equality. Gender-bending was the stuff of mass entertainment, from singer RuPaul, whose hit "Supermodel" was the decade's drag diva sensation, to the Disney-produced movies like *Birdcage*, which depicted the home life

of a drag queen and his/her partner. Drag queens were hot in the nineties, but drag kings were starting a fire of their own. But in 1997, no one was hotter than Ellen DeGeneres. The comedienne came out, not only in her personal life but also in her professional life in what was probably the most highly publicized announcement of its type. As an openly gay star of a prime time sitcom on a major network, DeGeneres managed to garner the prefix of "the first" in a number of categories.

IN 1998 President Clinton made another step towards establishing equality for the GLBT community in America by signing into law

ACT UP CONTINUED its assault on those who tried to suppress the gay community. Jesse Helms, the Republican Senator from North Carolina, was targeted in this shirt because of the anti-gay stance he repeatedly took in his political career. Helms was considered one of the most conservative voices in the government and during the controversy surrounding the National 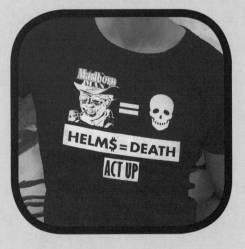 Endowment for the Arts' funding of photographer Robert Mapplethorpe, Helms led attacks against the organization and routinely spoke disparagingly of homosexuals. The senator's support for the tobacco industry, which obviously contributes to illness, was mocked as well in the shirt. ▪

an executive order that banned discrimination on the basis of sexual orientation for federal employees.

Frank Kameny, who had been a victim of this type of employment discrimination when he was fired

from his job in the fifties, told the *Washington Blade* that the president's signature heralded a "total victory which could not have been conceived when I was fired in 1957."

It was proving to be a year for such victories. A challenge to legislation that allowed gays and lesbians to adopt in the District of Columbia was beaten back by a group of Democrats and Republicans in the House of Representatives. Republic National Committee chairman Jim Nicholson spoke at a convention of the Log Cabin Republicans, the gay and lesbian Republican group in August of 1998. With the party most commonly associated with "conservatives"

signing laws protecting, and attending functions supporting a minority most often seen as the domain of "liberals" there was a sense that equality, on every level, was not merely attainable: it was inevitable. Such a display of inclusion and tolerance was a far cry from just two years earlier in 1996 when Republican presidential candidate Bob Dole had returned a check that the Log Cabin Republicans had donated to his campaign.

And then in October of 1998 the nation and the world witnessed a horrific manifestation of anti-gay violence. A college student at the University of Wyoming by the name of Matthew Shepard was

brutally attacked and left for dead.

As details of the attack came together, the story became more horrifying. Shepard was lured to his death by two young men who had asked him to go for a ride in their pick-up truck after leading him to believe that they were both gay as well. Once his attackers had him trapped they tortured Shepard by beating, burning and cutting him, finally stretching his bleeding frame over a fence.

Shepard clung to life for a week before dying on October 12, 1998. His death galvanized Americans, both gay and straight. Republican lawmakers turned out for a candlelight vigil on the steps of the Capitol Building in Washington, D.C. and stood side by side with Democrats and gay activists. The "stony resistance of many Republicans to federal hate-crime legislation melted amid rosy predictions it would be revived, and passed, when Congress resume[d] in January," wrote journalist Margaret Carlson.

While a hate crimes bill in 1990 initiated the collection of data on violence committed against homosexuals, there were still no changes to the current law that protected people of color, race, religion and national origin.

But January 1999 came and went without anti-

gay discrimination being added to the existing law.

Then in March, barely six months after Matthew Shepard's murder, Billy Jack Gaither was beaten to death in Sylacauga, Alabama. Gaither's murder was the result of two weeks of planning on the part of his attackers. According to the deputy sheriff of the Alabama county where Gaither's dead body was found beaten and burned, his assailants stalked and killed him because he was gay.

The following month President Clinton urged Congress to address the issue of hate crimes against the gay community. Citing a statistic that showed a hate crime occurred at the rate of nearly one an hour in 1997, the president called for the Federal Hate Crimes law to protect victims of crimes motivated by a bias against an individual's sexual orientation. He also suggested that a tolerance curriculum be taught to students of middle school or junior high age. The Family Research Council criticized the president's request, which was made the day after Matthew Shepard's murderers received life sentences in prison. Their reason; that the expanded hate crimes proposal endorsed the "homosexual agenda." Robert Knight, the Family Research Council's senior director of cultural studies, claimed that

condoning homosexuality by teaching children about tolerance and protection of gays and lesbians from attacks was "a hate crime against [those] parents" who taught their children that such a sexual orientation was wrong, or immoral.

Conservatives and the so-called "religious right" had been arguing that acceptance of gays and lesbians and a federal law protecting them from hate crimes would result in the violation of First Amendment rights, even though the courts had already decided in previous cases that freedom of speech was protected. But as Margaret Carlson had written in her essay for *Time* after the Shepard murder, "Words are one thing. Sticks and stones are another." It was the actions involving ax handles, like the one used to bludgeon Billy Jack Gaither to death, or the handle of the .357 Magnum that cracked Matthew Shepard's skull, that were the aim of advocates of the hate crimes bill.

"All crimes are hate crimes" was another familiar refrain from those opposed to granting the same protection to gays and lesbians. Maintaining that sexual orientation was a choice, the religious right and anti-gay factions argued that the granting of protective rights to individuals based on such a choice would be extending special rights; somehow the notion that one's

religion was a choice, a choice that had special protections, was always eclipsed in their rationale.

The idea that homosexuality was a condition that could somehow be changed was gaining momentum with certain organizations. Name-calling slurs, like Jerry Falwell's labeling of Ellen DeGeneres as "Ellen DeGenerate" or his insistence that one of the characters from a children's television show was gay were almost laughable compared to the insidious tactic taken by groups such as the Center for Reclaiming America. The conservative group aired television commercials in which a concerned mother gently implored other parents to save their children from the lifestyle of damnation: "Just because you love your children, it doesn't mean you approve of everything they do. Sometimes they make bad choices." Self-described Christians were adopting a so-called "love the sinner, hate the sin" approach to battling gay equality. In TV commercials and in full page newspaper ads, programs that were the "prayed straight" equivalent of the successful "scared straight" programs that helped steer juveniles at risk from a life of crime offered gays and lesbians a chance to change.

Taking the stance that

171

homosexuals were choosing to remain "sinners" became an effective leveraging tool in the political arena because it reinforced the idea that gays and lesbians were asking for special rights, based upon an orientation which they believed gays and lesbians had chosen; albeit rights that conflicted morally with a large block of mobilized voters. By playing the "compassionate conservative" card, right-wingers removed themselves from any culpability when it came to inciting violence or fostering hatred or any ill will at all towards homosexuals. Plus a little sanctimony went a long way. When gay-bashers were positioned in the courtroom as defending their manhood, there was a large support network that seemed willing to scold them with a wag of the finger but a shrug of the shoulders as if, "What would you expect them to do in the face of such a threat?"

THE PREDATORY HOMOSEXUAL

became newly demonized in the nineties. Jonathan Schmitz's defense team framed the shooting death of Scott Amedure, by Schmitz's hand in 1995, as the act of a man trying to protect his manhood from the advances of a degenerate. A similar angle was used in the defense of a policeman on trial for sodomizing another man with a broom handle

in 1999. The lawyer for the accused said that the victim was actually gay. His injuries were due to having had sex prior to his encounter with the cops. The man was not gay, but the jury was presumed to believe that homosexuals engaged in such violent behavior that, even if the victim had been raped and injured, he got what he deserved.

But such acts of hatred and such rhetoric weren't exclusive to civilian life in the last decade of the century. In the military the argument that the very presence of gays was disruptive to morale had been the source of dismissal or marginalization in its most benign forms, the cause of murder at its worst. The 1990s saw the death of Petty Officer Allen R. Schindler, in 1992, and the death of Private First Class Barry Winchell, in 1999, both killed by their fellow servicemen because they were perceived to be gay.

The "Don't Ask, Don't Tell, Don't Harass, Don't Pursue" policy the Clinton administration had been forced to compromise with in the wake of failed measures to lift the ban on gays and lesbians in the military was actually witness to an increase in anti-gay attacks and slurs. In April of 1998 the Department of Defense conducted its one and only study of the Don't Ask Don't Tell policy and reported that it

was a success, even though gay and lesbian service members were experiencing a rise in harassment. Discharges were also on the increase. The climate for homosexual soldiers was not changing for the better. "You're a dead faggot" was scrawled on the bunk of a gay sailor on the USS Eisenhower, while gay discharges increased from 17 to 200 at Fort Campbell, where Private Winchell had been stationed, in the months following Winchell's death. In 1999, the year of Winchell's murder, an increase in discharges of homosexuals from Lackland Air Force Base led Acting Secretary of the Air Force F. Whitten Peters to call in the Servicemembers Legal Defense Network to help uncover the reason for the high number of dismissals. The SLDN, a rights-and-watchdog group formed in the wake of the Don't Ask Don't Tell policy to help those who'd been affected by continuing hostility, implemented an awareness program that helped the Air Force base reduce the incidents of harassment and discharge at the Lackland base.

The unrelenting anti-gay atmosphere in the armed forces led to President Clinton's amending of the Code of Military Justice with an executive order that included sexual orientation in the prosecution, in court-martial, of hate crimes in the military. Once again detractors

pointed to the so-called "special rights" homosexuals were receiving, arguing that gays were not permitted in the military anyway so offering them protection was akin to granting them special privilege.

FOR EVERY DOOR that was opened, and every bridge crossed, the gay rights movement found there was still staunch resistance on their path to equality. The 1990s had witnessed an unprecedented cultural shift in America. An often forced political correctness—typified by the quickly uttered "Not that there's anything wrong with it" gag line from TVs *Seinfeld*—had been enacted enough that in some cases it actually had

given way to acceptance, while in other scenarios it only increased animosity. Was familiarity breeding contempt, as the old adage proposed? Was there a price to be paid for being out in America at the end of the twentieth century? Was the GLBT community asking and expecting too much from a society that historically chose to ignore it or persecute it rather than welcome it? Even gay author Andrew Sullivan, writing about hate and the topic of hate crimes, posited that as social beings humans associate with one another and therefore are bound to disassociate from one another as well. With public figures like Pat Buchanan claiming that the

idea of homosexuality induced a "visceral recoil" in him, there was no shortage of the counterpoint when arguing for tolerance of gays, let alone assimilation.

The century was coming to a close with several gay rights battles still being waged. The Federal Hate Crimes legislation remained stalled. While more states began adopting laws against anti-gay discrimination, it was often not without roiling debate. Same-sex marriage was another issue of contention, its opponents arguing religion rather than reason to state their case. And within many churches gays and lesbians were still framed as a threat to the social stability of the country. On the political horizon, the elections in the year 2000 were cause for anxiety, as one Republican frontrunner was not expected to be a friend of the GLBT community, despite labeling himself a "compassionate conservative." Clinton had angered

many gays and lesbians by compromising on the military's ban against gays. Some felt he'd betrayed the community completely by signing the Defense of Marriage Act. Yet it couldn't be denied that it was during his presidency that a fundamental shift occurred if not in the country than at least among gays themselves. Whether gay, lesbian, bisexual or transgender, more people were coming out and refusing to allow their happiness to be shaped by the intolerance of others.

The gay rights movement in the twentieth century had created an environment in which homosexuals had other choices about how they wanted to live their lives besides remaining in the closet or facing overwhelming alienation. Education and exposure were leading to understanding. There were more gays and lesbians living out, loving openly, and wearing their orientations with pride than ever before in the United States' history.

I've always loved the shirt that says 'That's MISTER Faggot To You.' It's a reclamation, an acceptance, an advertisement and a demand for respect all expressed in just five words. And it's funny.

STACEY SINGER

writer, musician

Marching On

THE DEBUT AND immediate success of *Queer Eye for the Straight Guy* in the summer of 2003 was enough to make people check their calendars. Given the social and political climate of the time it was astounding that a television show featuring five gay men offering lifestyle and grooming tips to a heterosexual protégé could become so wildly popular. But it was not only a testament to how gays had changed the way America looked (as the show's title and premise wryly noted) but also how GLBT visibility had changed the American landscape.

Gays and lesbians continued to play an undeniable contributing role in the culture in the new

ASKING "HOW MUCH LONGER" was as much an accusation as it was an appeal. Looking back over the twenty years since AIDS first appeared, it was almost unthinkable that it was still an issue. There was now an entire generation alive who had never known a time when AIDS was not a threat.

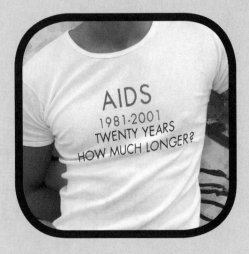

The shirt asked many questions: How much longer would it be before there was a cure? How much longer would it be before there would be a preventative vaccine? How much longer would people have to suffer? How much longer would drug prices be preventatively high? And why?

The shirt showed how much had changed since the first cases of AIDS were diagnosed, but it also was a sad reminder of how much remained the same. ●

millennium, despite stepped up efforts by political and religious special interest groups to change their orientations or—if that didn't succeed—keep their influence out of mainstream society. Outvoting the GLBT movement seemed to be one effective way for the right and its constituents to silence gays by voting for legislation that would deny them equal rights. This tactic, in turn, only created a call for greater visibility.

The GLBT movement had succeeded over the last thirty years in opening the closet door so that future generations would feel comfortable in crossing its threshold. Wearing a button or T-shirt that simply proclaimed one's orientation

was common now. The struggle to increase familiarity had shifted several times from the Stonewall era's call that gays and lesbians be seen and heard to more issue-specific fights in the ensuing decades.

In the first years of the new century the call for equality targeted matters of marriage and recognition of the validity of GLBT relationships. In an interesting twist, states would begin voting to essentially grant special rights—something that had long been the accusation leveled against proponents of gay rights—to heterosexuals making them the only members of society who could legally get married.

Starring in hit television shows,

establishing a lobbying presence and creating economic power all contributed to getting the GLBT movement's message seen and heard. But as gay and lesbian visibility grew in almost every aspect of American life, members of the community had to wonder what more needed to be done to secure equality for the future.

NOW THAT THE GAY NINETIES

had come and gone, what did it mean to be out and gay in the new century? The out community looked much different than it had forty years ago, thirty years ago or even ten years ago. In the 1990s life in gay America, as the media portrayed it, looked like Ellen DeGeneres,

Melissa Etheridge or Rupert Everett. Scenarios of same sex couples sitting on the porch swing of their country house with their adopted children, or images of gay partners buying paint for their fixer-upper at Home Depot portrayed life for gay and lesbian Americans as an existence free from strife and prejudice, where conversations about personal security dealt simply with bank accounts and financial futures, not threats of gay-bashing. This looked like progress.

Yet threats still remained.

THERE WERE STILL grieving

families losing loved ones to AIDS. America had become accustomed to seeing the pallid faces of those

suffering from the disease. Now they were seeing the last snapshots of Matthew Shepard and Billy Jack Gaither taken before they were beaten beyond recognition and left for dead.

What was the face of the GLBT community now? The events of the last thirty-plus years, and the formation of numerous organizations, should have created a visible minority as varied as the rest of American society. But criticism from within the gay community charged that despite its call for quality and inclusion, the group that the gay rights movement had seemed to benefit the most was predominantly professional and white. Accusations that the community's interests as a whole were being overlooked sparked the debates over the shape and future of the gay rights movement. It was reminiscent of the debates and disagreements that had caused gay organizations to splinter in the past. With the Millennium March on Washington scheduled for the spring of 2000, some GLBT activists feared that the push for equality in society could never be realized, especially when there was growing division among gays themselves. There was a growing concern that the most visible members of the GLBT community would be its most affluent, their financial stature allowing them to buy access.

IN THE NINETIES corporate America became more sensitive to the issue of equality in the workplace and some companies began granting the same benefits to domestic partners of homosexual employees as those available for heterosexuals. Corporate America also became savvy to the gay community as an economic force. Benetton may have raised eyebrows, and questions of decency, with its 1992 ad which featured a bedridden young man dying of AIDS with his grief-riddled family at his side, but the campaign was also a marketing tool designed to mine the gay dollar. And raise profits. Just as politicians had found blocs of voters in the GLBT community,

advertisers and corporations found a ready-made market. Long having been the objects of ridicule and social marginalization, some gays and lesbians had distanced themselves from the world that had rejected them, seeing the prejudice that had cast them out as evidence of their antagonists' ignorance and lower intellectual and aesthetic capacity. That elitism made them a perfect target for high-end retailers who were buying access through the very product they were selling. Daniel Harris' painfully direct observations in *The Rise and Fall Of Gay Culture* bemoaned the mainstreaming of gay culture. By appealing through glamorous advertising to what had

once been a badge of exclusivity in gay circles, corporations and luxury labels were recognizing that endorsing equality was good for business. Unfortunately, economic equality was as nonexistent in the GLBT community as it was in the straight world. As plans for the Millennium March were discussed, critics of the gay rights movement's most visible leaders felt groups like HRC were too preoccupied with "buying in;" selling out the interests of their constituents in the process.

The gay rights movement had made gays a viable market. Advertisers spent millions in slick ads for gay publications like *Out* and *Genre* while alcohol, car and clothing manufacturers sandwiched their sales pitches between scenes of *Will & Grace* (and later, *Queer Eye for the Straight Guy*). Sponsors for the Millennium March included United Airlines and the premium cable channel, Showtime. Cultural and corporate inclusions were signs of progress but discrimination and exclusion were still very much a part of everyday life for gays, lesbians, bisexuals and transgender Americans. Urban gays and lesbians might have had a false sense of security: The openness with which they were able to live did not reflect the nation's GLBT population as a whole.

Just as early activists and protest organizers had quarreled over the

movement's direction in the past, gay rights advocates in the twenty-first century were asking, "What *are* we fighting for?" The thrill of access, detractors noted, seemed to have muddled the focus on issues. Audiences with political figures and increased media representations were upping exposure but they weren't necessarily changing minds or changing policies. Americans remained divided over the issue of homosexual rights, with the majority still feeling uncomfortable with the idea of granting the same privileges to GLBT persons as those available to heterosexuals. With 2000 being an election year there was anxiety that the momentum gained during Clinton's administration could be undone as a backlash from the increasingly powerful Republican conservatives threatened. California voters were being asked to consider Proposition 22 in their state's primary elections in March of that year. The proposition was brought to the table by Republican State Senator William Knight and asked that "Only marriage between a man and a woman is valid or recognized in California" be added to the California Family Code.

By declaring himself against same-sex marriage, the senator drew a line in the cultural sand. The fight Knight picked was one in which candidates who opposed the measure

would be branded extremist, either liberal or immoral. With debates over whether or not denying same-sex couples the right to marry violated a constitutional right in the Hawaii and Vermont courts lingering from the previous decade, conservatives were banking that the issue could be used as a means to galvanize voter turnout. Now Vermont was poised to allow civil unions between same-sex couples; the topic of gay rights was again a powerful and effective political tool. Presidential candidates were testing the waters. Vice President Al Gore and Senator Bill Bradley had both condemned the California proposition, while their Republican counterparts

Senator John McCain and Texas Governor George W. Bush did not. McCain had already been criticized for meeting with the gay Log Cabin Republican group. Speaking out against Proposition 22 would have been perceived as an alliance McCain was establishing with gays, and one that would have alienated some Republican voters. The Texas governor had originally campaigned for the Republican presidential primary on the fact that he had turned down an invitation to meet with the Log Cabin organization, including it in radio commercials produced by the Christian Coalition. But Bush reversed his decision and eventually met with the gay Republican group in April of

THE 1990S AND THE new millennium saw corporations courting their gay and lesbian clientele in a variety of ways. Sleek ads in magazines like *The Advocate* or *Genre* showed that advertisers knew their demographic's spending habits.

The corporate response to AIDS and the sponsorship of events and benefits had been growing since the late eighties. It continued through the nineties and by the year 2000 was common enough that signage was the norm. Alcohol and apparel companies like Tanqueray and Banana Republic helped promote such fundraisers as the multi-day AIDS Ride event, vying for top billing on the T-shirts given to participants. Some gay activists feared such branding threatened to dilute the culture, turning a subset of society that once fiercely embraced its individuality and creativity into a superficial target market defined by what its members could buy. ∎

2000. Though he stated afterwards that the meeting didn't change his stance on same-sex marriage, he told reporters that he felt that he was "a better person" for having met with the Log Cabin members. With the Millennium March slated to parade through the nation's capital at the month's end, the presidential hopeful carefully stated that he hoped "conservative Republicans [would] understand we judge people based upon their heart and soul; that's what this campaign is about." The "compassionate conservative" was a persona Bush appeared to try on for the cameras, as gay Republicans urged him to allow a homosexual speaker to take the stage at the Republican

National Convention that summer. Doing so would have outraged the Christian conservative base Bush had been wooing, especially since he'd previously assured Christian radio correspondents that "An openly known homosexual is somebody who probably wouldn't share my philosophy."

By his comment the then-governor was taking the nation back forty odd years to a time when homosexuality was not discussed, except in terms of condemnation and alienation, not acceptance and inclusion. In Bush's opinion as expressed in his statement, homosexuals were not supposed to be "open" or "known." Gays

IN THE GRAPHIC tradition of *The Rocky Horror Picture Show*'s logo—and character Dr. Frankenfurther's homeland of "Transexual, Transylvania"—the Transsexual Menace T-shirt playfully riffed on the nervousness displayed by some gays and lesbians regarding the issue of transsexual rights' inclusion in the community's platform. While issues of gender identity had long been part

of the academic discussion of gay and lesbian orientation, the legalities of transgender individual rights were often an afterthought, or even a stigma. Lobbying for the "T" in GLBT rights became a necessity, as many states had no protection at all for transgender persons. ▪

and their orientations were to remain anonymous, invisible, essentially in the closet.

By using this type of rhetoric in addressing conservative crowds, the presidential candidate positioned

himself as someone on their side in the argument over gay rights. He distanced himself even further from the Clinton Administration's attitude towards gays with his refusal to back a federal hate-crime bill that would include anti-homosexual violence by simply saying "I believe that all crime is hate."

The right wing of the Republican Party was seeing to it that gay rights would be the divisive issue in 2000's elections, and with the battle over same-sex unions in Vermont ending in April with a victory for gays and lesbians, the conservatives could stress the urgency that was necessary to prevent this potentially explosive demonstration of love from spreading any further.

Arguing that the sanctity of marriage and the cohesiveness of the family unit were threatened by same-sex unions, conservative Republicans and some Democrats warned of a great unraveling of the nation's moral fabric if gay and lesbian relationships were to become recognized in a federal court. (Oddly there was no mention of the fact that heterosexuals had managed to dishonor the very institution they were claiming to protect by having divorced, abused and cheated on one another for centuries without any interference from homosexuals.)

The decision in Vermont's Supreme Court also came just

days before the national GLBT community's Millennium March on Washington, DC. Aside from the fact that large gatherings of gays had always been media fodder—footage of leather clubs regularly seemed to make the evening newsreel—and a way for anti-gay groups to get equal airtime and galvanize their grassroots, the Millennium March also illuminated the ways in which the gay rights movement had not changed in the nearly-half century since its inception. Infighting over the course of the movement's agenda still continued. But what was surprising to some straights and some gays was that same-sex marriage rights held no interest for a number of GLBT individuals. For them, marriage was an institution that belonged to the straight world, and therefore they wanted no part of it. Gay rights and gay freedom meant the right to live according to their own social codes, not those imposed by straight society. The March itself was an issue of contention for a group that called itself the Ad Hoc Committee for an Open Process. The securing of the before-mentioned corporate endorsements were seen, by this group, as being more important to the March's organizers than equal representation of the GLBT community.

The most important factor for the majority attending the march was not

so much the agreement on specific issues, but the display of a large unified movement. As the Millennium March's executive director, Dianne Hardy-Garcia, told *The New York Times*, visibility during the election year was a "judicious use of resources." With the threat of an anti-gay presence seizing the White House through November's ballot, gay rights' activists needed to show that the right wing was not the only political group that could rally its voters.

The Millennium March had no sooner ended in Washington than gays and lesbians took to the streets to celebrate another gay rights milestone, the 30th Anniversary of the first Christopher Street Liberation Day parade in New York. It had been thirty-one years since gays and lesbians had their we're-not-gonna-take-it moment at the Stonewall Inn riots in June of 1969, and now thirty years had passed since the first march commemorating that event, in June of 1970, had made its way through the streets of the Big Apple.

BOTH THE SPRING MARCH in the nation's capitol and New York's pride parade in the summer of 2000 were vantage points from which to look back at how far the gay rights movement had come since it took its first steps out of the closet and into the streets. Dissention was still preventing a

wholly unified movement, but much had indeed changed. Same-sex couples were about to be recognized by state-sanctioned civil unions in Vermont. Some Christian sects like the Presbyterians had begun performing blessings or union services for gay and lesbian couples. Parents and friends now walked proudly alongside their GLBT family members and cohorts. The First Lady and the Mayor of New York publicly expressed their support of their gay and lesbian constituents by joining the celebration in New York (while President Clinton and Vice President Gore addressed the crowds at the Millennium March in Washington by video).

The first barrier to gay equality was all but removed. Society no longer leaned against the closet door as heavily as it once did, though coming out was a long way from being an effortless passage. Visibility and exposure had led to dialogue, and dialogue had encouraged tolerance. Tolerance had even been transformed into welcoming acceptance in some cases. Many GLBT persons were being met with open arms in their families and in their communities, at their jobs and occasionally even in their temples, churches and synagogues. The days of being completely on the outside, whether of society or the political process, were over, but

gays and lesbians found that there were still limits to their freedoms and their rights. In the summer of 2000, nearly 75 percent of the states in the country still had no laws protecting gays and lesbians from discrimination in matters of housing or employment. Same-sex couples were barred from marrying in over half of the states, and consensual homosexual acts between adults were illegal in over a third of the states. Progress had been made, but with the conservative opposition to gay rights gaining ground, the election of 2000 was of particular importance as regards GLBT equality.

November came and went and when the election was awarded to the Republican candidate, George W. Bush, despite Vice President Al Gore's capturing of the majority of the popular vote, the future, or at least the next four years, looked grim for the gay rights agenda.

IT WASN'T LONG after Bush moved into the White House that the first rumblings of the cultural climate's change became evident. Most gays and lesbians were not anticipating a friendly tone from the administration despite candidate Bush's attempts at presenting himself as the so-called "compassionate conservative." The then-governor of Texas's meeting with the Log Cabin Republicans and his comments about considering

"the heart and soul of a person" were nothing more than attempts at reaching the moderate Republican voter, and possibly any Democrats unsure of their candidate's potential. Early in his candidacy he had declared himself a "Don't Ask Don't Tell guy" when addressing the issue of gays openly serving in the military while the Democrats' candidates all called for an end to the ban.

The welcoming tone and plans for inclusion that characterized Clinton's first candidacy for the presidency were not heard from Bush or his team. Instead the word compassion was repeated often as if simply saying it would somehow make the speaker enact it, or convince the listener to believe it. Six months into Bush's presidency he refused to issue a proclamation declaring support, or even recognition, of the annual Gay Pride celebration in the District of Columbia. Bush's silence was in remarkable contrast to the proclamation in the summer of 2000 in which Clinton called upon the nation to "recognize [GLBT persons] for what they are: our colleagues and neighbors, daughters and sons, sisters and brothers, friends and partners." When questioned about the president's refusal to follow in his predecessor's footsteps, White House spokesperson Scott McClellan said,

"The president believes every person should be treated with dignity and respect, but he does not believe in politicizing sexual orientation."

The Bush administration instead had Secretary of Transportation Norman Mineta sign a Gay Pride proclamation.

The proclamation was typical of the new president's arm's length handling of issues pertaining to gays and lesbians. By not speaking directly he avoided controversy. By having others speak on behalf of his administration he could maintain his position of "compassionate" conservatism; no one would misconstrue his statements as an endorsement.

ON TUESDAY MORNING,

September 11th, terrorists hijacked four commercial airliners and, using them as missiles, killed over 3000 men, women and children in what was the most catastrophic terrorist attack on American soil in the history of the United States. As the nation grieved and looked for ways to cope with the tragedy, some of those looking to place the blame pointed their fingers at familiar scapegoats. Just as gays and lesbians had been accused of Communist spying and were considered security threats in the middle of the twentieth century, they now became the unlikely targets of wrath and condemnation in the wake of the 9/11 attacks.

The harshest statements came from religious groups, not surprising given religious hard-liners' long-held interpretations of the Judeo-Christian bible's judgment of homosexuality. Failing to see the irony that their own fundamentalism was as narrow as that of the terrorists whose actions and extremism they deplored, several Christian religious figures made very public anti-gay statements in the aftermath of September 11th. A Reverend Louis P. Sheldon from the Traditional Values Coalition lobbied for the denial of assistance to the partners of gays and lesbians killed in the attacks; two days after the attack, on September 13, 2001, televangelist Jerry Falwell appeared on preacher Pat Robertson's TV program, 700 Club, and said "I really believe gays and lesbians…helped this happen." When a number of gay and lesbian rights groups, along with People For The American Way, accused Falwell of hateful and misdirected his speech, he explained his statement by saying "various groups had so offended God that the attacks could occur."

It was the Reverend Fred Phelps who staged the most despicable display. Six months after the September 11th attacks, Phelps and his followers, who'd gained notoriety for appearing at funerals of AIDS victims with placards reading "God Hates Fags," protested at Brooklyn's 9 Metro Tech

Center accusing the "fag ridden" New York Fire Department for contributing to the September 11th attacks by provoking God's anger.

That this type of rhetoric was engaged in so easily showed how engrained bigotry against gays and lesbians was in some parts of American society. But the quick rebuke by various media outlets including the *Washington Post*, the *New York Times* and ABC News was a display of how much the gay rights movement had achieved: Decades earlier the newspapers had been less than sympathetic when discussing the issue of homosexuality, and the idea that a news personality like Diane Sawyer would ever grill someone and hold them accountable for homophobic slurs on national television would have been unthinkable forty years ago.

As the United States mounted its campaign to root out those who'd planned, funded and supported the terrorist attacks, military operations were put into play. The number of discharges for homosexuality in the armed services plummeted by thirty percent in the fall of 2001, yet training materials in the Army and Air Force were soon found to contain words like "faggot" and questions such as "Do you intend to engage in homosexual acts?"

With the Bush Administration focused on the post-September 11th

state of the world as well as the hunt for terrorist mastermind Osama bin Laden and his al Qaeda network, conservatives found that terrorism and gay rights could be linked together if packaged as threats to the nation's stability. On one hand, gays were an easy target. Conservatives could point to the relative freedom of the gay community in America as an example of the cultural decadence that the Muslim extremists found so repulsive. On the other, playing the homosexual immorality card allowed conservatives and the religious right to suggest that gay rights would further weaken the country against future attacks. Gay adoption rights were held up as one example of how America's family values were disintegrating, and of course gay marriage was demonized as the ultimate evil, the legalization of which would leave cultural destruction inevitable.

A SIGN THAT compassion was trumping conservatism in the new millennium was the granting of benefits to surviving partners of gays and lesbians who were killed in the September 11th attacks. Yet its slow issuance once again showed that rather than reason through their old prejudices the anti-gay factions chose to continue endorsing an archaic condemnation of homosexuality. Opponents of gay

rights had historically pointed to Judeo-Christian texts, most famously the Book of Leviticus, singling out a passage that referred to same-sex couplings as an "abomination." Yet they studiously ignored the other so-called evils, some punishable by death, that were also contained in that same passage—including strict codes on beard length, the wearing of the opposite gender's clothes (which would make women in pants a crime before the Lord), kosher laws (which would make every pork barbecue pit a gateway to hell) and the allowance of a menstruating woman into the house only in the evening. Failing to see the historical context of these codes of law—that the recipients, the Israelites, were a persecuted people who needed to strengthen their ranks to ward off future enslavement and would need to increase their army by being physically strong and capable of procreation—opponents of gay rights remained narrowly focused on this so-called divine directive forgetting that modern society had already dispensed with many of the other Mosaic laws contained in Leviticus, most notably slavery. But interpretations of these texts, especially when they suited someone else's political or ideological agenda, had helped keep minorities oppressed for centuries. Even some white supremacist groups pointed

IN SOME RESPECTS the freedom to live and work where one wanted was protected more than the right to love who one wanted, even in the new millennium. Proponents of full partnership rights for same-sex couples found resistance not only from anti-gay factions but also among gays themselves. Hard to believe that the relatively harmless word—marriage—

could be so divisive in the GLBT community, but advocating same-sex marriage was seen by some as an adoption of the straight world's conventions and the last abandonment of true gay freedom. For supporters, the right to marry was essential to full equality. ●

to Biblical passages to support their bigotry towards any race that wasn't Caucasian, forgetting of course that Jesus himself was not white.

But such rationality was not employed, nor was there

the chance of dialogue between gay rights advocates and those pitted against them, especially not when homosexuals were being likened to terrorists.

THERE WERE GLIMMERS of hope for the GLBT community in 2003. Just weeks after Attorney General John Ashcroft had informed gay, lesbian and bisexual employees at the Department of Justice they could not hold annual Pride celebrations on the premises in June (though other employee groups were not forbidden from gathering or meeting on the grounds), the Supreme Court decided a major victory in favor of gay rights. In the case of *Lawrence v. Texas*, the Court ruled that consensual gay sex between adults in the privacy of their own home was indeed protected by the United States Constitution. That the ruling addressed a case in Texas, President Bush's home state, made the win even sweeter. At the time of his placement in office in 2000, same-sex acts between consenting adults were illegal in eighteen states, Texas being one of them.

October of 2003 witnessed the ten-year anniversary of the Don't Ask Don't Tell policy and was marked by calls for the ban on gay and lesbian service to be lifted, with several high-ranking— but retired—military officials publicly stating their disapproval

of the continuation of the ban.

Then in November of that same year, the Massachusetts court decided that same-sex couples should be entitled the same privileges as straight couples in matters of state-recognized marriages. The court said that "barred access to the protections, benefits and obligations of civil marriage, a person who enters into an intimate, exclusive union with another of the same sex is arbitrarily deprived of membership in one of our community's most rewarding and cherished institutions. That exclusion is incompatible with the constitutional principles of respect for individual autonomy and equality under law."

As the debate over the constitutionality of same-sex marriage carried into 2004, political candidates seized it as an issue to elevate themselves while denigrating their opponents. President Bush parroted the phrase "activist judges" and threatened to invoke the "constitutional process… to defend the sanctity of marriage." Those in favor of banning same-sex marriage with a constitutional amendment didn't see themselves as "activists" though they had a clear agenda, intent on writing bigotry and discrimination into the Constitution in their zeal to deny marriage rights to same-sex couples.

WITH THE NOVEMBER elections for 2004 on the horizon, political candidates continued staking out their claims on the issue of same-sex marriage. As Bush threatened a constitutional amendment to define marriage exclusively as a contract between one man and one woman, more and more states began adding the issue on their own ballots to prevent gay marriage from becoming part of their cultural landscape. "Marry Me!" was plastered across the front of T-shirts worn by same-sex marriage proponents while non-profit organizations like Freedom To Marry held fundraising events to promote awareness: Hundreds of benefits were guaranteed and available to heterosexual couples while same-sex couples were not even assured visiting rights in hospitals should their partner fall ill. Meanwhile political candidates began lining up at the podium to denounce same-sex marriage as immoral. Massachusetts Democratic presidential candidate John Kerry said he backed civil unions but not gay marriage, while Vermont's governor, Howard Dean, announced his support for civil unions. Republican Majority Leader Bill Frist called for an amendment to the Constitution that would outlaw gay marriages.

San Franciscans proved as feisty as ever when city Mayor Gavin Newsom granted marriage licenses

WITH THE FIGHT for equal rights generally fought on local and national levels, it's easy to lose sight of the global fight. Many countries still have laws making homosexual acts punishable by death, and gay resources have published lists of nations where GLBT travelers should exercise caution. With a call to stop the persecution of gays and lesbians on an international

level, the Stanford University Day of Silence Tee and the event it commemorates is a reminder that until everyone is free, no one is actually free. ●

to same-sex couples in time for Valentine's Day of 2004. Though the 2000 election in California added language to the state's books that defined marriage as being a union between one man and one woman only, Newsom charged that denying same-sex couples the chance to marry coincided with California's anti-gay discrimination laws.

While some in gay-rights circles criticized Newsom, his actions as well as those of the couples who stood up to receive their marriage certificates from the city's City Hall were reminiscent of former San Francisco "actions" taken in the past. As charges that gay-marriage proponents were only fueling the right's hate machine by giving them more issues to wedge between groups of voters, those in favor of same-sex marriage began viewing the anti-gay marriage faction within the GLBT community as Uncle Toms who were acquiescing to conservatives out of fear.

Once again the old and unfortunately familiar arguments about the extent to which gays would fight for their equality were rekindled.

Those opposed to same-sex marriage within the GLBT community were likened to the early homosexual activists who had a hat-in-hand approach to inching the movement forward, while the those in favor of gay-marriage rights were enacting the spirit of Harvey Milk, who had galvanized gays to seize the power they weren't given thirty years earlier.

And just as in Milk's era the anti-gay factions had their mouthpiece, so those opposed to gay marriage had their hate speech. Pennsylvania Senator Rick Santorum claimed

that gay marriage threatened his own marriage and likened same-sex marriage to bestiality, finally calling the prospect of gay marriage a threat to homeland security.

Once again, gays were categorized with terrorists.

THE PRESIDENTIAL ELECTION

in 2004 was won in a legitimate manner this time by incumbent Republican George W. Bush who immediately promised to spend the capital he'd thought his victory had earned him. Understandably that expression worried gay rights proponents. Politicians did not vote upon the Federal Marriage Amendment but the anti-gay campaign rhetoric was enough to place anti-gay discrimination issues, in the form of banning gay marriage, on numerous state ballots. Those votes resulted in excluding same-sex couples from the rights afforded through the legal contract of marriage.

What would be next?

The first year of Bush's second term held a surprising victory for GLBT individuals when the House of Representatives voted in favor of adding language to existing laws that would protect gays, lesbians and bisexuals from hate crimes. The September 2005 vote stunned many as the House had previously blocked a similar

vote the year before when the Senate had voted for legislation that would have included sexual orientation to the list of offenses covered by hate-crime laws.

In June of 2006, a similar victory for gay rights advocates came when the proposed Federal Marriage Amendment, which would have banned same-sex marriage through the addition of a Constitutional amendment, failed to garner enough votes. Opponents of the amendment, both Republican and Democrat, cast their votes on the basis of a refusal to "write discrimination into the U.S. Constitution."

Wear It

IN THE MONTHS leading to this book's publication, the following events have occurred.

● Former professional basketball player John Amaechi became the first NBA star to openly declare his homosexuality. In the days following this announcement reactions in the sports world ranged from admiration—on the part of out tennis champion Martina Navratilova—to blatant loathing: One NBA player publicly stated his "hate" for gays on a radio talk show.

● A Southern Baptist minister announced to his followers that

there was compelling evidence that homosexuality had biological origins—before adding that parents who opted for prenatal intervention to change the orientation of their child would be "biblically justified" in doing so.

- General Peter Pace, Chairman of the Joint Chiefs of Staff, told the editorial staff of the *Chicago Tribune* that he believed homosexuality was immoral. His remarks drew a rebuke from the ranking Republican senator on the Senate Armed Services Committee.

- And with contenders for the presidential election of 2008 already testing the tolerance levels of their constituents, the two leading candidates from the Democratic Party answered vaguely when asked initially if they agreed with Pace's assessment of homosexuality.

GAYS AND LESBIANS might be hard-pressed to view these scenarios as encouraging for the future of GLBT equality. But the fact that there is reporting of such topics, without the judgmental tone that the media formerly employed is one sign of the progress of the last four decades.

Dialogue will eventually lead to lasting change. Announcements like Amaechi's will continue to inspire more people to come out,

while statements like Pace's will add to the determination of the movement's leaders to confront ignorance with education. Exposure and visibility will remain key components of that education while a consensus on the most effective means of communication will be, as it has been since the earliest days of the push for equality and gay rights, the stuff of debate.

AS I WAS COMPLETING this book, a friend sent me a photo that he thought was relevant to the subject matter and a perfect example of how the GLBT community has worn its history. The picture, taken at a Pride celebration in Washington, D.C. in 1987, showed a young man wearing a T-shirt that proclaimed "I Violate Article 27, Sec 553-4 of the Maryland Annotated Code SAFELY, OFTEN and EXTREMELY WELL." The text referred to Maryland's sodomy laws on the books at the time.

The T-shirt's message was provocative and effective, and considering the year it was worn—1987—it was also very brave. The use of the words "violate" and "safely" could lead viewers to deduce what "Article 27, Section 553" entailed, while the first person assertion made the wearer's status clear. He was, according to Maryland law, a criminal. (The sodomy law in Maryland was struck

AN AFFIRMATION OF resilience, strength and determination, the statement speaks to the community's growth ever since the λ was first appropriated on T-shirts over thirty years ago. The declaration might owe a debt to Gloria Gaynor's disco anthem, "I Will Survive," but changing the pronoun to the plural "We" sends a message to those who try to challenge

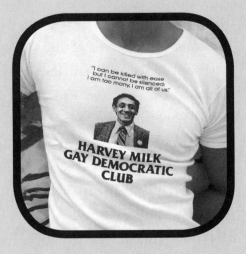

the movement. As Harvey Milk had said famously said "…I cannot be silenced. I am too many, I am all of us."

In declaring "We Will Survive," the statement assures all of those who might feel marginalized—regardless or because of their sex, gender, orientation or even political affiliation—that they are not alone. ∎

down eleven years later, in 1998.)

Today, that same shirt would be understood by most anyone abreast of current events. Along with T-shirts with slogans like, "Transsexual Menace," "AIDS 1981–2001 Twenty Years: How Much Longer?," "Lift The Ban!" and "I Love My Mommies," the fact that such messages taken from the vantage point of the twenty-first century are easily identifiable is either remarkable or mundane, depending on which generation you belong to. For activists who have fought for gay rights, often through perilous acts, the relative ease of this kind of visibility is never taken for granted. After all, they helped to earn it. For younger GLBT persons

the ability to wear such a slogan in public might not even merit a second thought; why should these expressions be whispered or hidden? And they're correct in their thinking. They should have the right to feel safe, serve in the military, marry their partner, adopt children and assume their gender identity. And everyone should have hope that AIDS will be eradicated in their lifetime.

The reality is that gay men, lesbian women, bisexual individuals and transgender persons in America do not have the same rights as others. There are still five states that have laws denying same-sex couples or gay and lesbian parents the right to adopt or serve as foster parents while nearly

half of the country's states do not have any laws on the books—leaving denial open for a court's decision. Despite a recent victory in New Jersey for same-sex marriage advocates, Massachusetts is now the only state currently issuing marriage licenses to gay and lesbian couples. Even though United States troops fought side by side in Iraq with military units from nations that allow gays and lesbians to serve openly, the ban on out homosexuals to serve in the American military remains intact. And transgender persons are only protected from employment discrimination in ten states.

But there is progress. The Federal Hate Crimes bill is closer than ever to being passed, persons with AIDS are living longer, better lives, and some activists would argue that the mere participation in dialogue about all of these issues puts the GLBT community one step closer to equality. Gays are no longer on the outside of the social or political process but are actively involved in shaping their own, and the rest of the country's, destiny. Still there are limits to that involvement. In a nation where church and state are supposed to be separate entities, numerous religious leaders have used their parishes' pulpits to sermonize congregants to vote against anti-gay discrimination. Politicians have had great success bashing the

"homosexual agenda" as being inconsistent with their values when courting conservative voters.

The gay rights movement's gains will always be limited as long as there are closed minds. But as visibility and exposure have shown, a mind once stretched to include a new idea, to paraphrase Oliver Wendell Holmes, never returns to its original dimensions. Through perseverance, the GLBT community will change history by wearing history and—as the T-shirt attests—ultimately survive.

BIBLIOGRAPHY

Berube, Allan. *Coming Out Under Fire: The History of Gay Men and Women in World War Two.* New York: The Free Press, A division of Macmillan, Inc. 1990.

Carter, David. *Stonewall, The Riots That Sparked the Gay Revolution.* New York: St. Martin's Press, 2004.
Chauncey, George. *Gay New York: Gender, Urban Culture, and the Making of the Gay Male World, 1890-1940.* New York: Basic Books, 1994.

Constantino, Maria. *Men's Fashion in the Twentieth Century: From Frock Coats to Intelligent Fibres.* New York: Costume & Fashion Press, an imprint of Quite Specific Media Group Ltd, 1997.

Duberman, Martin. *Stonewall.* New York: Plume, Penguin Books, 1993.

Harris, Daniel. *The Rise and Fall of Gay Culture.* New York: Ballantine Books, 1997.

Hooven, F. Valentine III. Tom of Finland, His Life and Times. New York: St. Martin's Press, Stonewall Inn Editions, 1993.

Kaiser, Charles. The Gay Metropolis: 1940–1996. San Diego, New York, London: 1997.

Loughery, John. The Other Side of Silence: Men's Lives and Gay Identities: A Twentieth-Century History. New York: John Macrae/ Owl Book, Henry Holt and Company, 1998.

Paglia, Camille. Break, Blow, Burn: Camille Paglia Reads Forty-three of the World's Best Poems. New York: Pantheon Books, 2005.

Shapiro, Peter. Turn The Beat Around, The Secret History of Disco. New York: Faber and Faber, Inc, 2005.

Shilts, Randy. And The Band Played On, Politics, People, and the AIDS Epidemic. New York: St. Martin's Press, 1987.

Shilts, Randy. The Mayor of Castro Street, The Life and Times of Harvey Milk. New York: St. Martin's Press, 1982.

Stryker, Susan and Jim Van Buskirk. Gay by the bay: A History of Queer Culture in the San Francisco Bay Area. San Francisco: Chronicle Books. 1996.

Waugh, Thomas with Willie Walker. Lust Unearthed:Vintage Gay Graphics from the DuBek Collection. Vancouver: Arsenal Pulp Press, 2004.

Waugh, Thomas. OUT/LINES: Underground Gay Graphics from Before Stonewall. Vancouver: Arsenal Pulp Press, 2002.

ACKNOWLEDGMENTS

I can't thank my agent, Dave Dunton, enough for always believing in this book as an independent project deserving of print and attention. And I thank Joe Pittman and Alyson Books for giving *Wearing History* a home. Likewise immeasurable gratitude goes to Jacob and Terrence and the rest of the staff at the GLBT Historic Society in San Francisco who allowed me to commandeer their research room as I rifled through boxes for hours on end.

I especially thank my parents for always loving me and always being proud of me, even at those times when they didn't like what I was wearing.

And as always I thank my partner Lon who supported this project, as he has all of my other endeavors, with unconditional love and unwavering support, simply because it was mine.